Daylight

Rubi Lebovitch **HOME SWEET HOME**

Cofounders: Taj Forer and Michael Itkoff
Design: Ursula Damm
Copy editor: Elizabeth Bell

Photographs © 2015 Rubi Lebovich
Text pp. 5–8 © Eran Bar-Gil
Text pp. 11–13 © Crista Dix

ISBN 978-1-942084-13-6

Printed in Turkey, by OFSET YAPIMEVI

Daylight Books
E-mail: info@daylightbooks.org
www.daylightbooks.org

The Tangled Guts of Home

If home was a body
I would plunge my hand into it
and pull out the guts
like a predator dividing
prey from prey
and I would tangle up
these guts and force myself
on the quiet relationship
between the walls of home and its corners,
on the people who exchange pain
exchange jealousy and small-talk
in the comfortable world of togetherness
in which the image of
home as body
is not alien to the eye reading a poem
is not alien to the eye nor heavy on the heart
nor the fact that the tangled guts of the house —
live. Microcosmic, miniature
a portion, a half-portion
a short lesson in love.

—Eran Bar-Gil

DIVIDING LINE
On the Work of Rubi Lebovitch
by Eran Bar-Gil

It all happens at home. In the sheltered, secluded place. Quietly undermining its serene foundations, creating a sense of foreboding. A woman is knitting a sweater directly onto her body, wool threads scattered on the floor around her. Or perhaps she is unraveling it. Her serene demeanor and the mundane, domestic nature of her activity are contrasted with the impossibility of her actions. Another woman, no less serene, places her hands into the toaster as if they were two slices of bread. Precisely at home, in the protected, private place—terror lurks: in the kitchen, in the living room, in the bedroom, in the familiar and intimate corners. Terror hovers in the children's room where two cribs rest side by side, two cribs made up with clean sheets, and above them ripped posters that seem intentionally damaged, darkening the atmosphere. In spite of these inviting, made-up cribs, it is clear that no one would put their children to sleep in such a disturbing room. Scanning the room in an attempt to understand what is so unnerving about it, one discovers that the cribs' safety bar faces the wall. It cannot be used.

Sometimes the sense of the uncanny is created by extremities (a picture hanging on the wall, surrounded by endless nail holes representing failed prior attempts; a never-ending bunch of keys) and sometimes by unacceptable combinations (a bookshelf in which all the books are facing the wall or a bouquet of flowers made up of stems alone). Lebovitch takes things out of context and builds a different connection to create a sense of impending doom—like a scarecrow in the kitchen. The scarecrow, resembling a homeless person, is positioned in the center of the house as both the thing itself and its complete opposite. It provides a note of opposition and protest, against the backdrop of a threatening sky. The dining table tied up in chains has also been rendered useless. And, like many other domestic objects treated by Lebovitch, it undergoes personification and represents the absent occupants of the house (such as the babies absent from the children's room), chained to themselves, to their family, to this home.

When the occupants of the house do appear, they are as grotesque as the chained table: wound up in toilet paper, eating spaghetti off an oversize tray, placing hands inside a toaster. They are neutralized—like the couch that is tipped up at an angle. What is left for a person wrapped up in toilet paper? To what purpose does a man peep through a keyhole in a door taken off its hinges and installed in the center of the room, at what can be seen more clearly outside the boundaries of the door frame? Everything happens at home. All arrows are directed inward, focusing on the obvious that has been removed from its milieu. Multiplied, exaggerated. The movement between logical and illogical, serenity and terror, is also expressed by the dividing line, a dichotomy, splitting the visual space into its opposites: a tidy living room that is clean and homely, bordering on a a temporary, disordered wall made of carton that looks like it is about to collapse; a chunk of fresh butter placed next to a melted one; toy horses in the daytime next to the same horses that have been cut up into strange shapes at night. At times the dividing line, symmetric and clear, passes through the center of the image, such as in the works that are split into two (the images of the butter and the horses); at times the line crosses at a diagonal (the tipped-up couch). At other times the line is thematic, ideological, a line that separates the image into two parts: the acceptable, the logical, as opposed to the surrealistic, the ironic, and the illogical (a carpet whose insides have been ripped out).

The home has many keys. Some belong to the man who stands in the undefined space of home, with a bunch of keys hanging, as expected, from his waist. But his set of keys is so long it reaches the floor; it becomes a burden to him, pulling on the hem of his pants like a root that shoots out of the floor and grips his leg, dragging him down. The keys, like tree rings, reveal time. They reveal the time of this man, standing there in the house. We know, even without seeing his face, that he is despondent.

At night the home
deepens into itself,
cradling breaths within its walls like a child
who cradles a ball, proving its existence
through the fridge's murmurings
and the tired creaking of books.

They sleep close to each other, far apart
in dreams, limp and quiet
as inanimate objects

and together they draw near
to glistening maturity, turning
over one into the other like two pups.

The flower vase knows how to tell
of their love
better than words.

—*Eran Bar-Gil*

UPON CLOSER INSPECTION

by Crista Dix

Approximately two billion images are uploaded to the Internet every day.

The way we see the world around us is overwhelming, drowning us in visual culture. The simplicity of snapping a photo, uploading it, sharing it, and sending it to family and friends is so easy that content and context are often unassuming, even irrelevant, potentially immunizing us to a photograph that's not only a great image, but also has something to say.

In this oversharing context, do we really look at what matters to us? With these billions of images on our social media sites, do we really *see* anything at all, let alone register the simplicity and meaning of our lives?

Rubi Lebovitch's work *Home Sweet Home* reminds us to slow down and invites us to explore each frame carefully. With humor and wit, he shows us that in looking back at ourselves, we find not an overwhelming similarity, but our ridiculous differences and fixations. Lebovitch asks us to participate in his work, to engage with him in a dialogue that is far from serious, but does ask us questions about our own foibles. His images reveal what happens when sanity runs amok. By elevating the mundane and exaggerating the obvious, Lebovitch asks us as viewers to look a little harder, pointing out our compulsions and quirks as humans with laughter and playfulness.

In Lebovitch's artist statement he references Camus and the theater of the absurd. His work partakes of the same concept: the images are just plain funny, overflowing with sublime farce. This is not a series designed to achieve world peace, but one that reiterates our bonds to family and home, looking at the oddities and eccentricities we all share. It is the element of whimsy, of satire, and of the narrative of the absurd that makes this series worth looking at over and over, finding nuance and innuendo in each image.

The contradictions begin at the start, with the series title *Home Sweet Home*. Our expectation of home is a place filled with comfort, somewhere we can land after being out in the world with the unknown. At home we know where everything is, what it smells like, feels like; we can wander in the darkness of our surroundings and still feel safe. It is where we ground ourselves and recharge our souls. Lebovitch pulls the rug out from under us. His vision of home is slightly

skewed; in every image something is ajar. Where we keep our keys, how we hang our pictures, how our plants are potted, even the way we organize our garage. The simplest of objects become fodder for satirical mischief.

It is Lebovitch's attention to the minutest detail of incongruity that makes these works special. We are led into each image without realizing that potential disaster lurks around the edge of the frame. Each shot must be carefully scrutinized, for the essence of humanity is evident in every one. Whether a human form is present or not, the evidence of our impact is clear somewhere within the photograph.

In *Gobelin* we see a framed tapestry of a Swiss mountain chalet hanging on the wall. What an interesting wallpaper pattern. Wait, take a closer look. It has depth, chaos, no linear quality to the lines….They are nails. Lots of nails. All surrounding the print. How many of us have pounded a few holes before we get the right one? Lebovitch leaves it all hanging out for us to see, not hidden behind the volume of frame. The nails mirror the needlepoint, adding depth and texture to the wall. Our obsession with a perfect white wall marred and filled with holes.

Lights finds us in a hallway. Soft warm light is emanating from a… wait. What? On closer examination we see a nightlight, supported by a stack of outlet extenders. Our assumption of a wall sconce, the item we expect in our mind's eye, slowly gives way to what Lebovitch has crafted. Shining a light on our presumption of understanding, leaving us surprised and bemused by the object at hand.

In his specific detailing of the surroundings of our lives, Lebovitch has crafted stories about nothing, much like some of the greatest episodes in Seinfeld, the beloved iconic sitcom of the '90s. The photographer highlights the break between convention and expectation. His images are filled with ideas that disappear into the background yet inhabit each corner of the composition. It is a delicate operation in which art and object intersect without distortion of either.

Normalized senselessness abounds: *Plant* connects us to the great outdoors while being inside; *Pacifiers* is a collection of baby binkies buried amid the books, keys, and knickknacks we all stash in the place where we shove things we don't want to see. Like the un-potted plant, the objects end up in the corner. The images of knitting oneself into oblivion in *Wool*, the extra laces in *Shoes*, and the unbearable weight of *Keys* all lend themselves to silliness, pointing up our irrational preoccupations with our things.

Historically, many photographers have looked to interiors as visual clues to who we are. In what we surround ourselves with, we identify our innermost desires, needs, and comforts. Are the images we take merely the release of our therapeutic need to discuss space and the ways we inhabit it? Great photographers such as Jeff Wall investigate and celebrate the human psyche, as Lebovitch does, by looking inward. Where Wall employs humans in the frame, Lebovitch more often looks to the contents of the space that imbue the interior with character, defining the inhabitant. Thomas Ruff's earliest works, *Interiors*, also seek to capture the mindset of residents by identifying the personality of the fixtures, wallpaper, and objects within the frame. While Wall taps into our psyche with serious purpose and Ruff senses the loneliness and solitude of belongings, Lebovitch gives us entrée to our humanity via our follies.

Lebovitch asks, who or what is in control of this situation? As with the chicken-and-egg co-nundrum, do we give power to the objects that surround us, or have they wrested control from us? In his world the focus of each frame is the object first, the human after. There is a certain witlessness in believing one can control one's environment. Chaos theory involves the idea that humans cannot control nature, and we have certainly seen that come to pass when nature overtakes manmade objects: roads, bridges and buildings, shelters from the storms. But is it also human nature to give inanimate objects control over our psyche? It is in Lebovitch's world: he exploits concepts that remind us of a bad science fiction film where the objects come to life to haunt humans, inducing a quirky contemplative paranoia where nothing is quite right and everything is rife with possibility.

The eccentricities and wit of Lebovitch's photographs identify the best and worst of our culture. Memorializing the banal, the everyday, his work imparts a deep understanding of our strengths and defects as a culture—and at the same time makes us laugh out loud. It makes us think, reminds us of our shortcomings, but also rallies our strengths.

In our lives, as in pop culture, we inhabit a place of silliness, the mundane, the absurd. It is this home sweet home that Rubi Lebovitch lives in, and, to our delight, shares with us.

Books (2010)

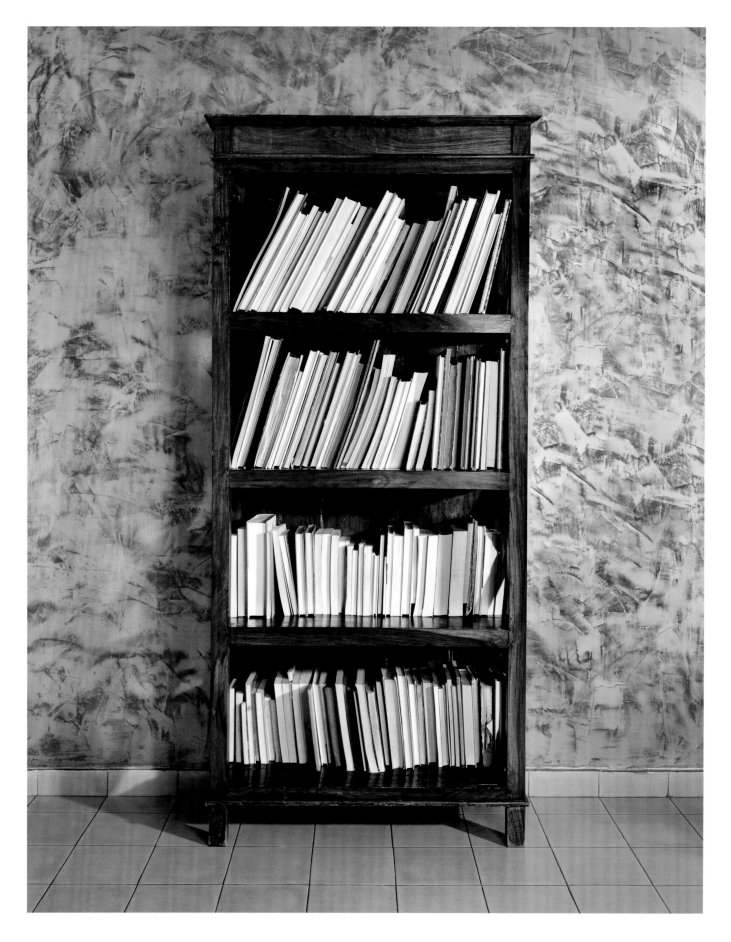

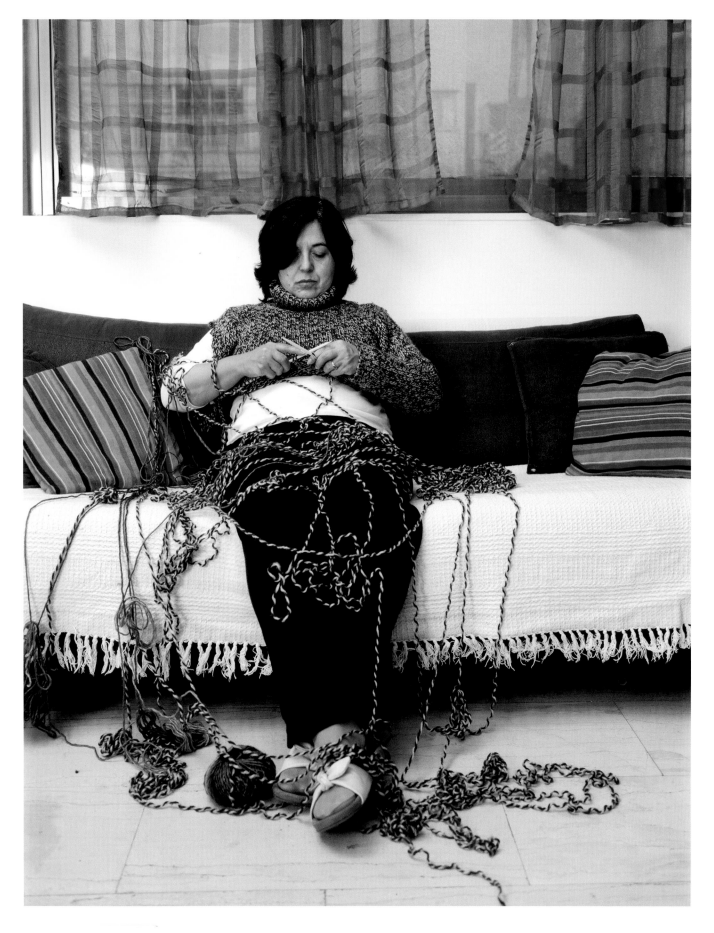

Wool (2009)

Sofa (2011)

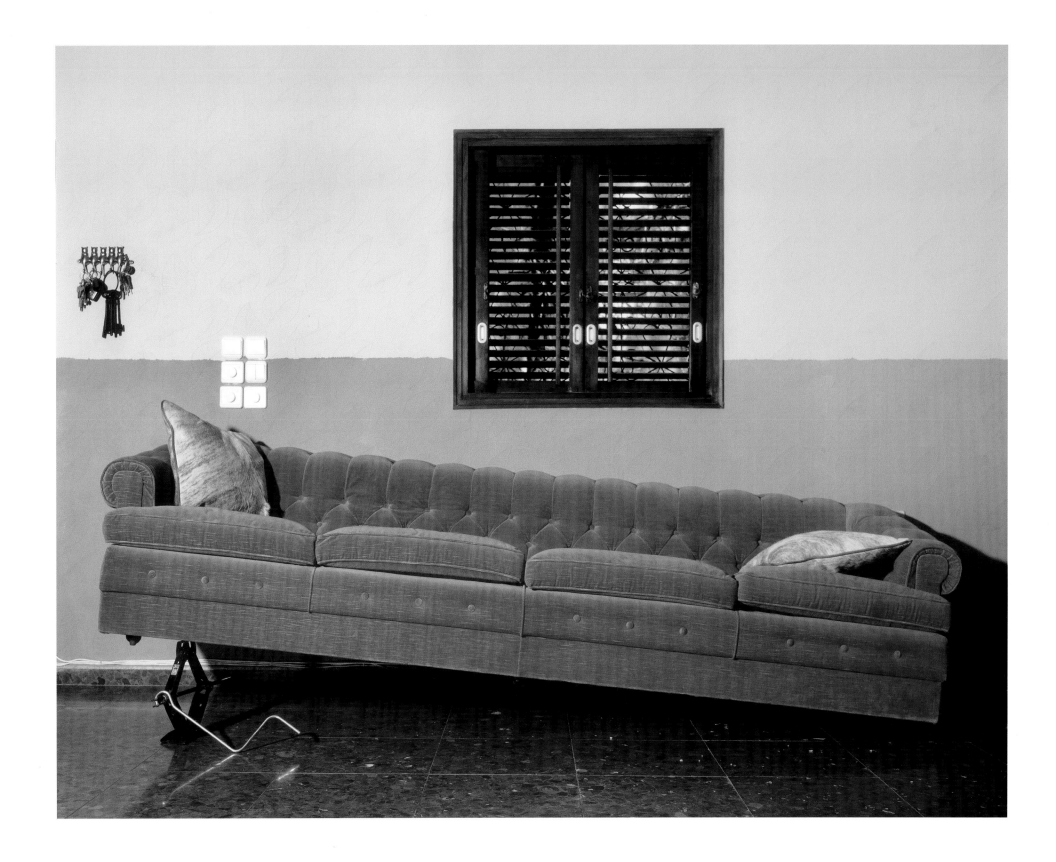

Bathtub (2015)

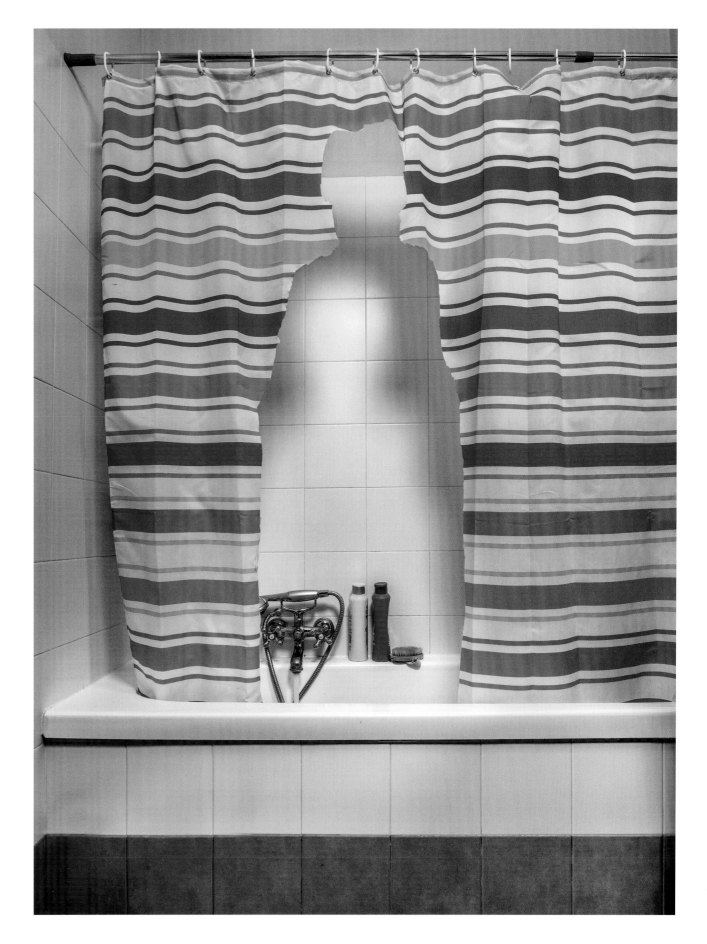

Flies (2009)

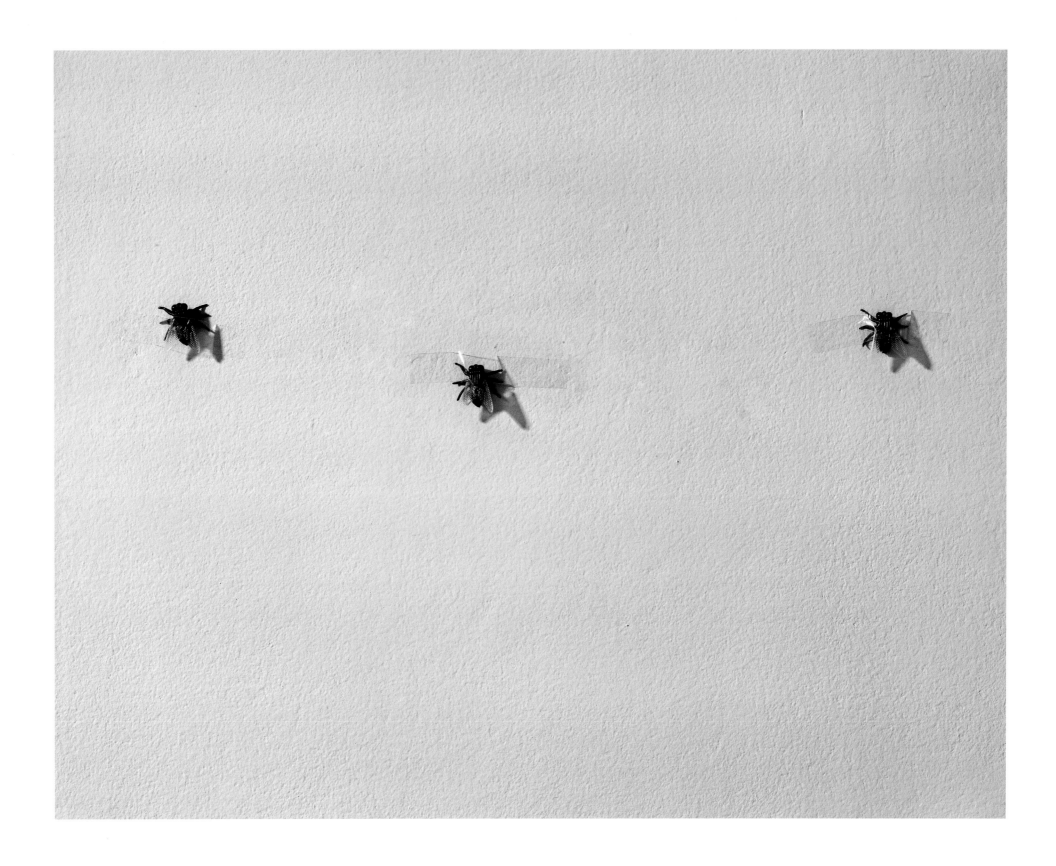

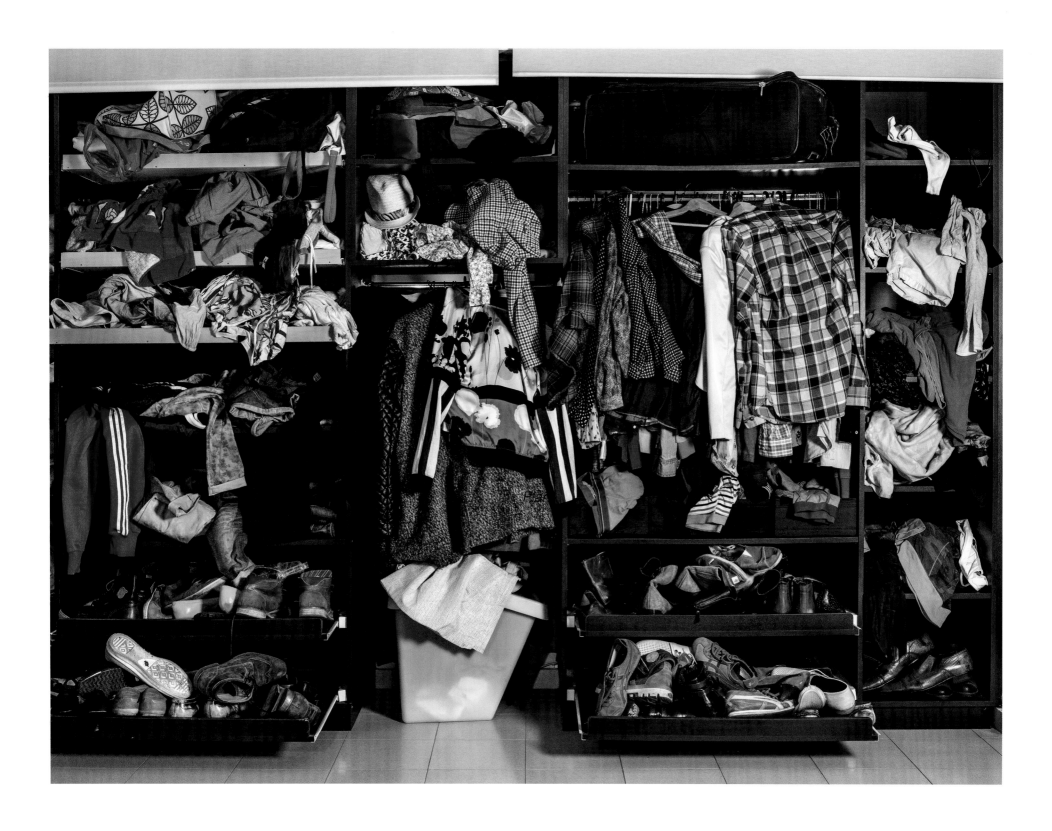

Closet (2015)

Carpet (2010)

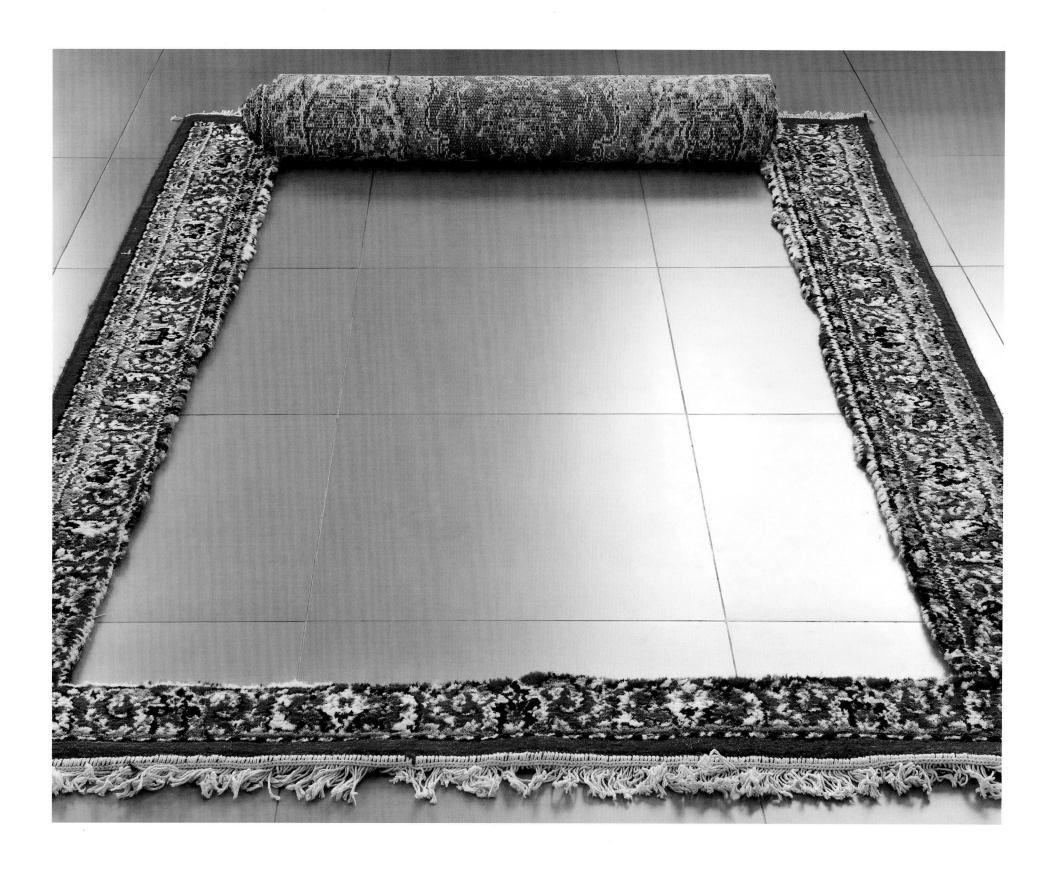

Keys (2009)

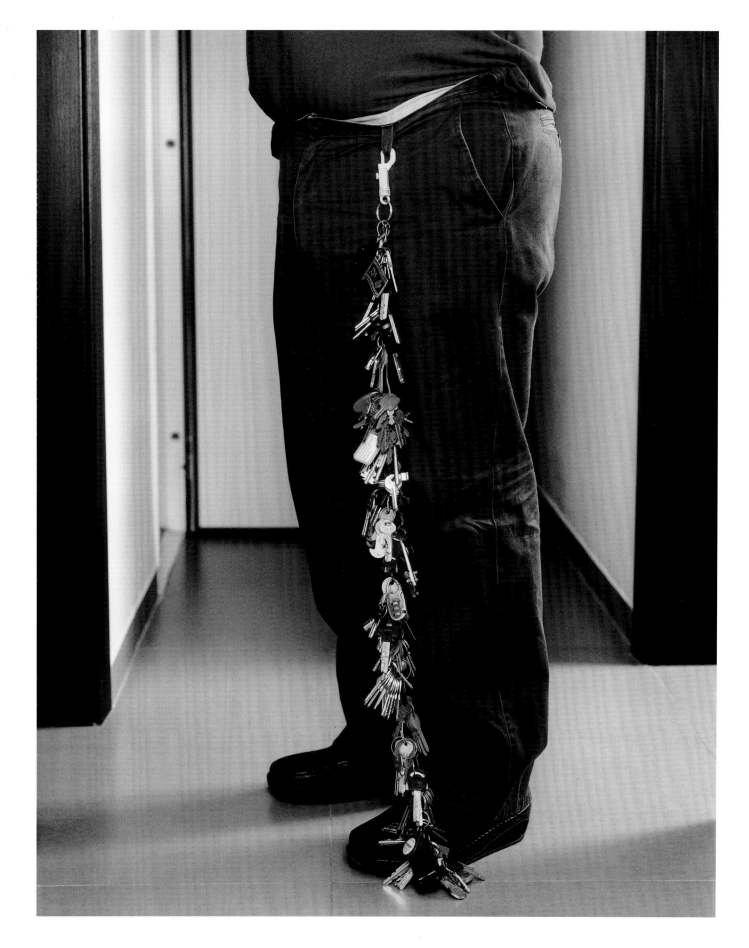

TV (2015)

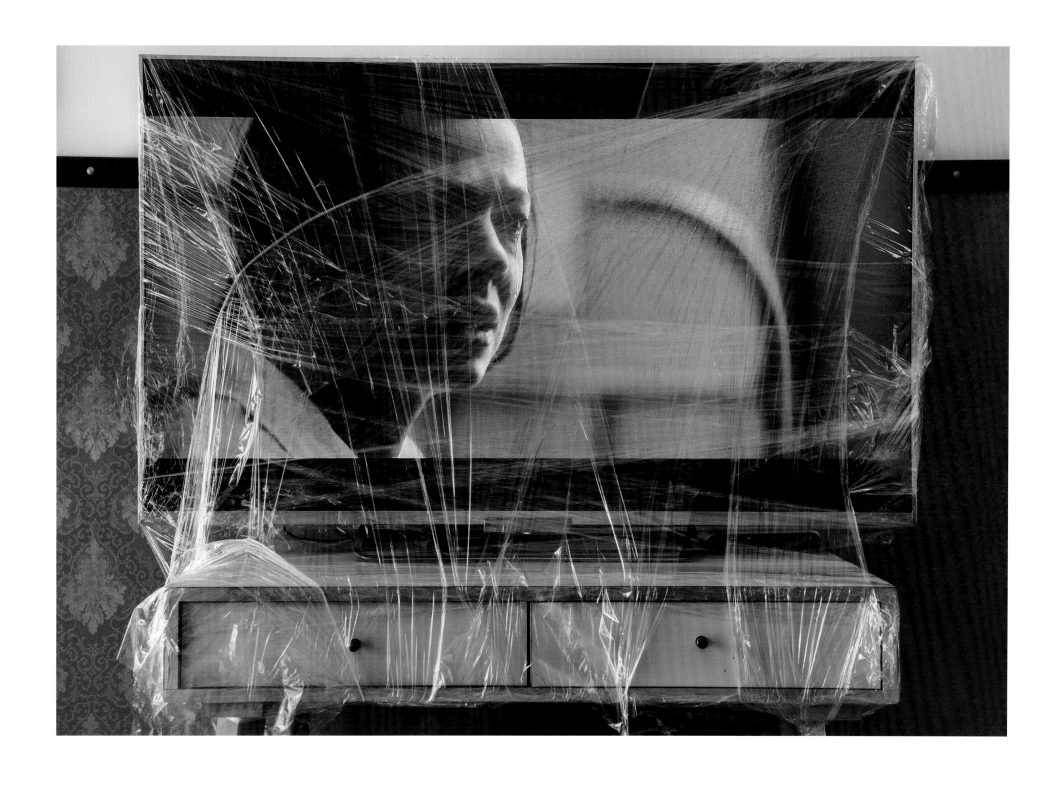

Plant (2008)

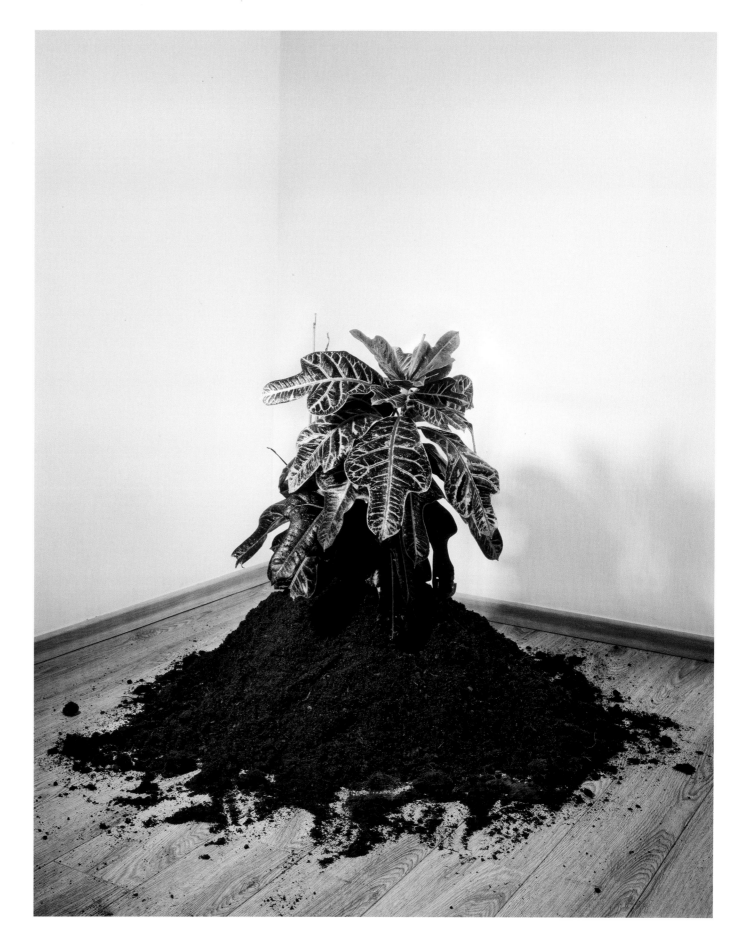

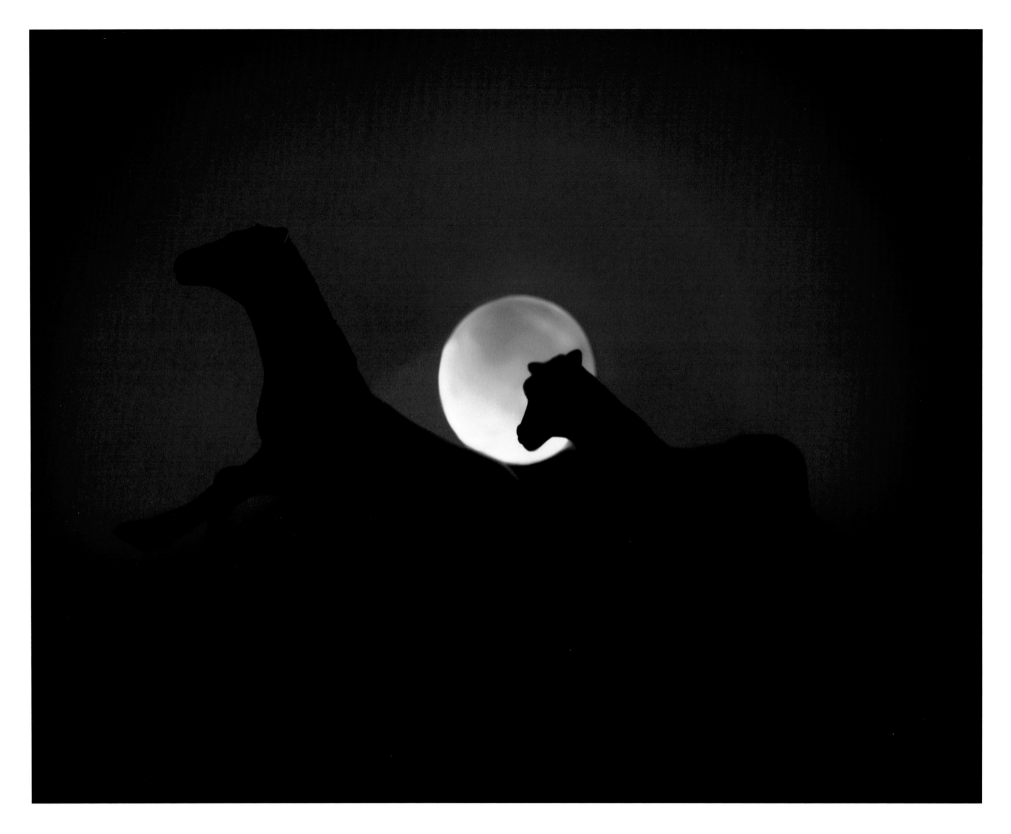

Horses (2010)

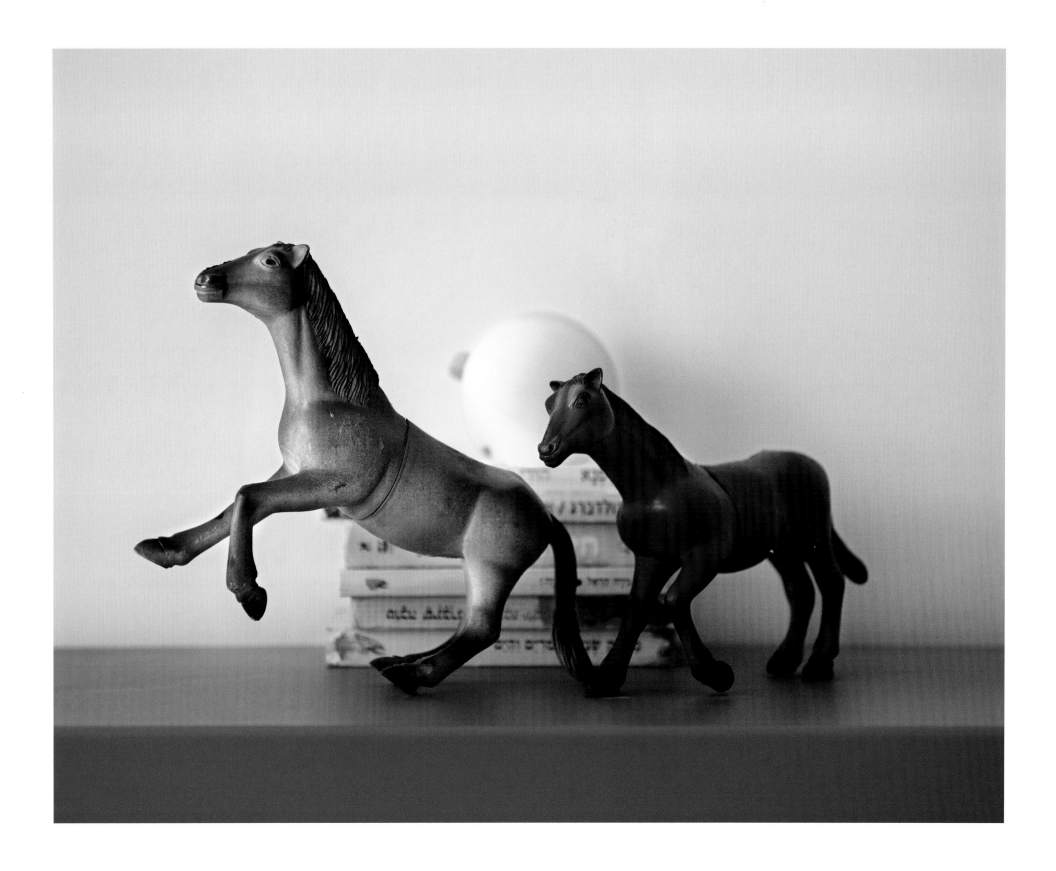

Newspapers (2015)

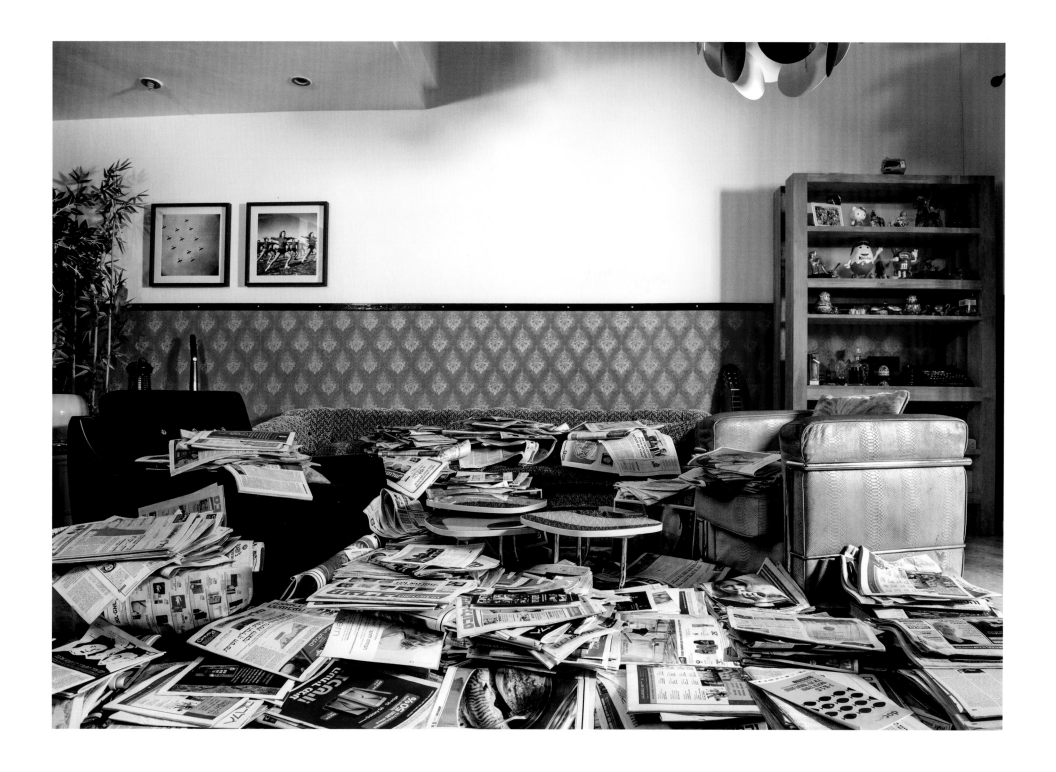

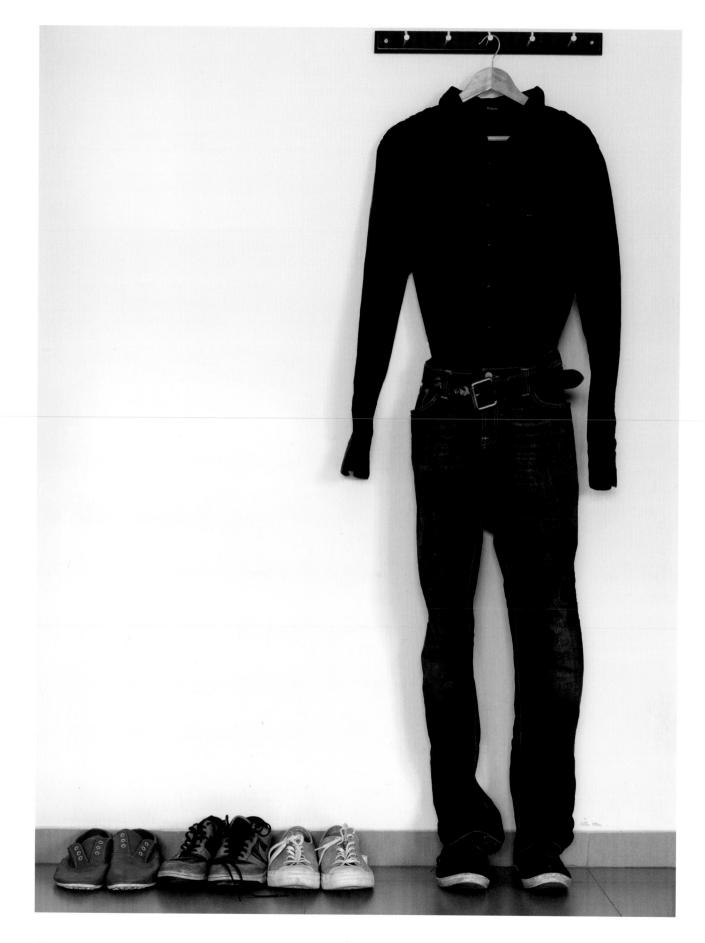

Hanger (2013)

Toilet Paper (2008)

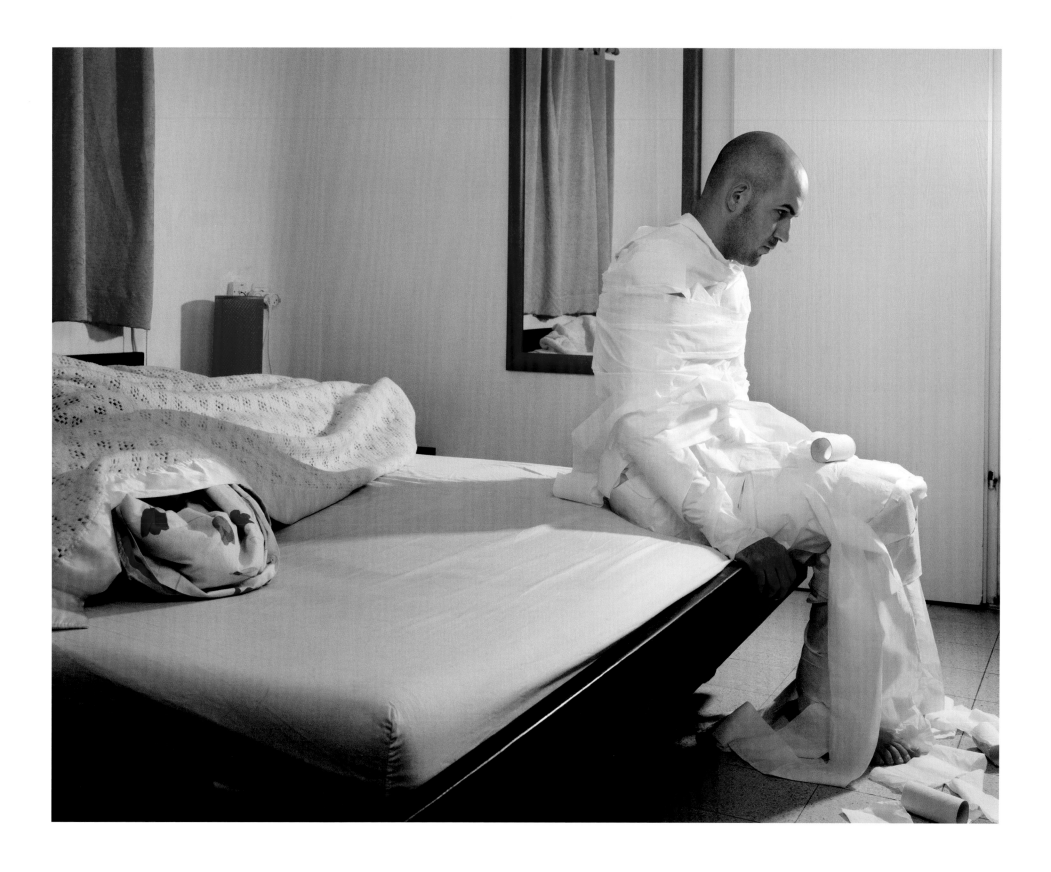

Boxes (2010)

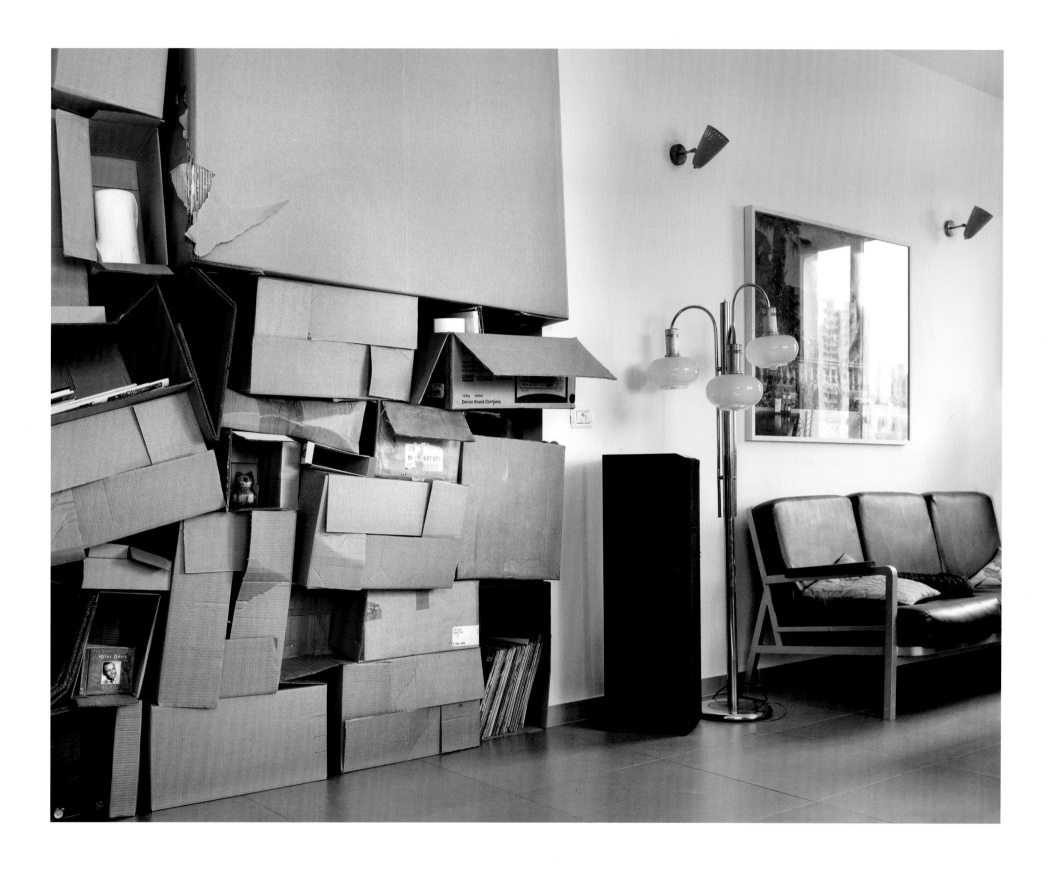

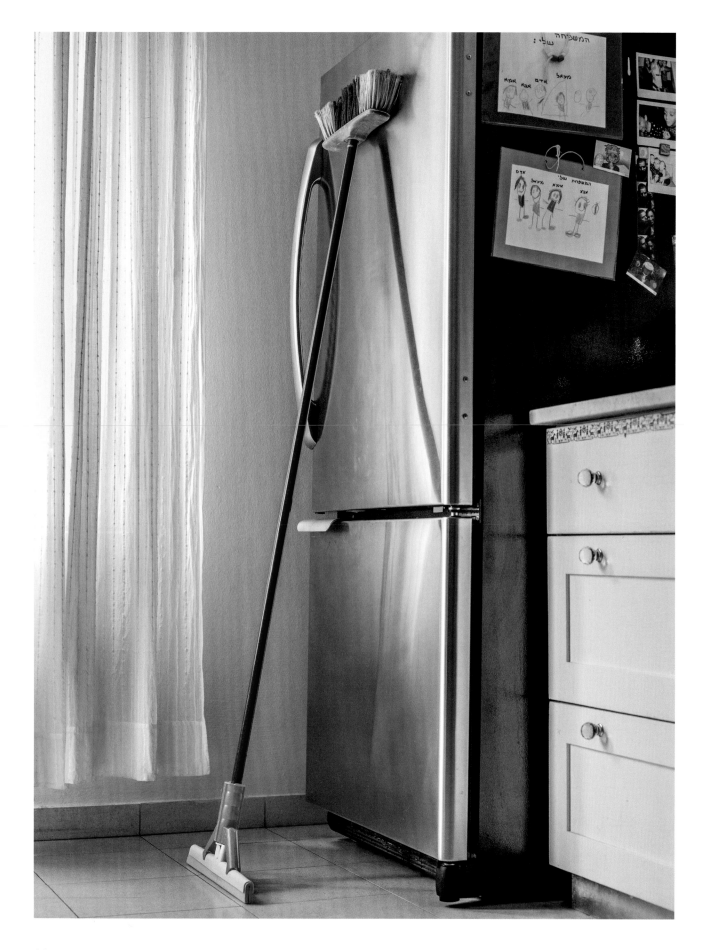

Broom (2014)

Toaster (2014)

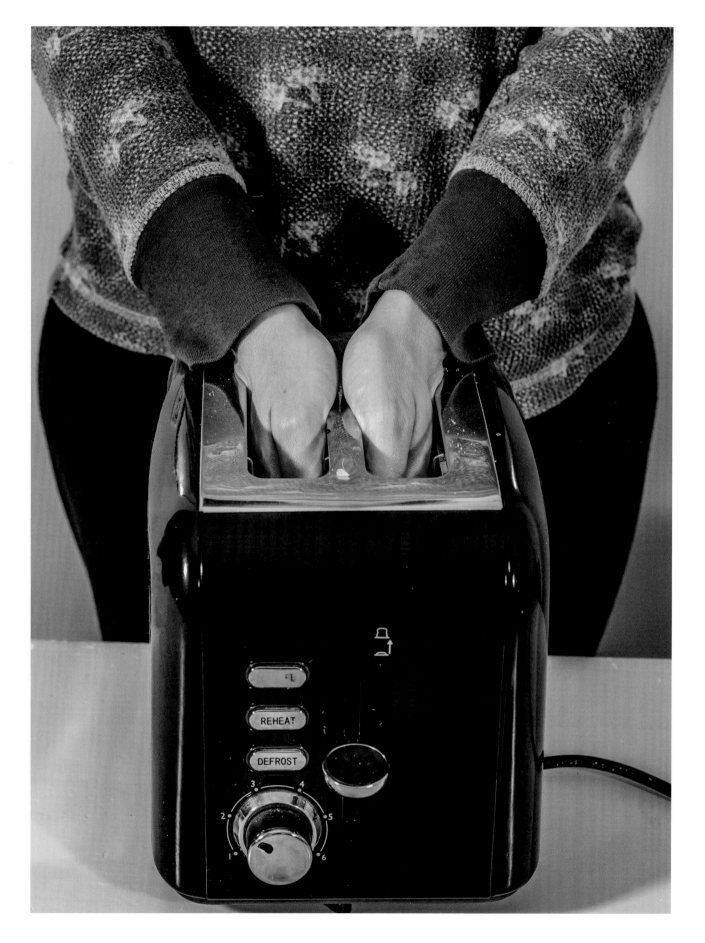

Window (2014)

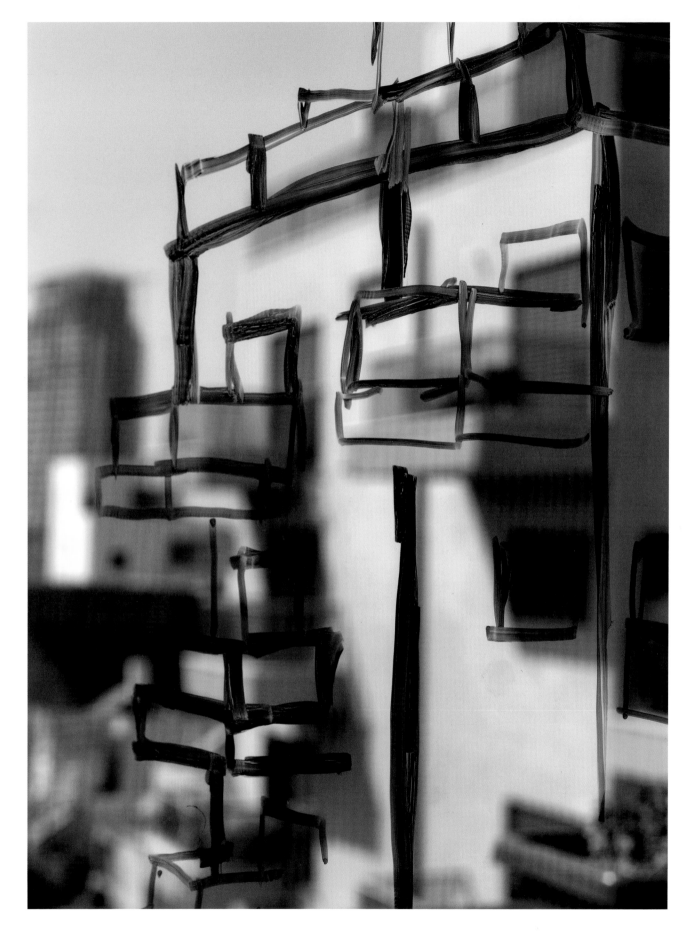

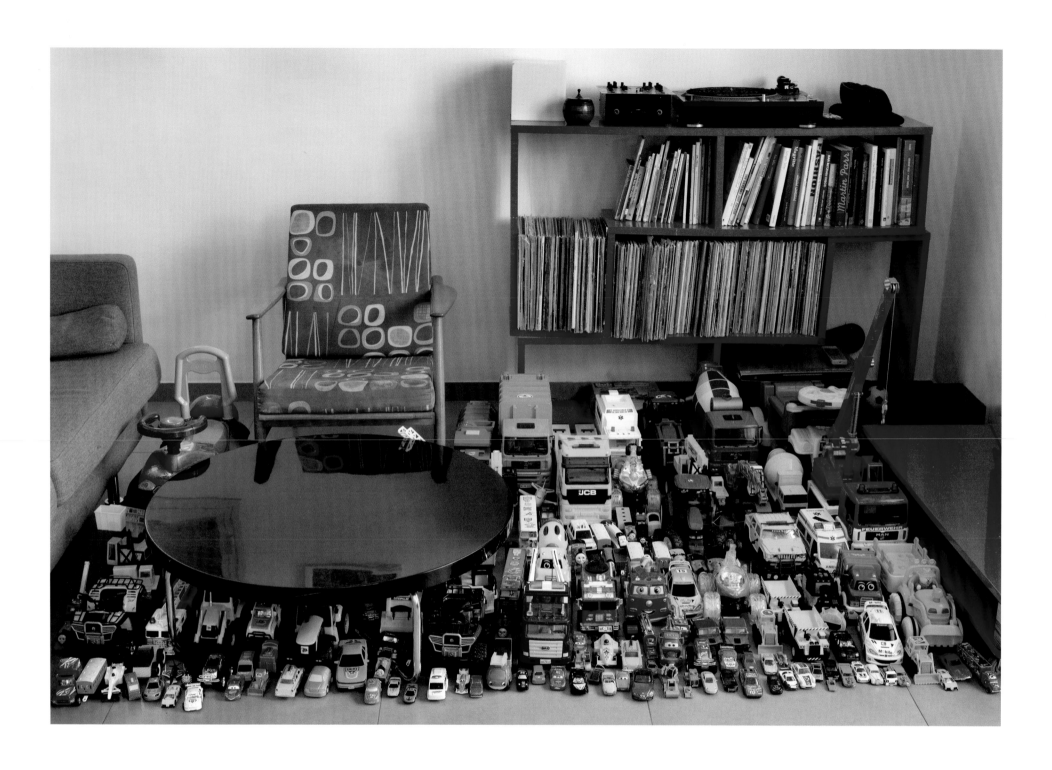

Cars (2012)

Iron (2015)

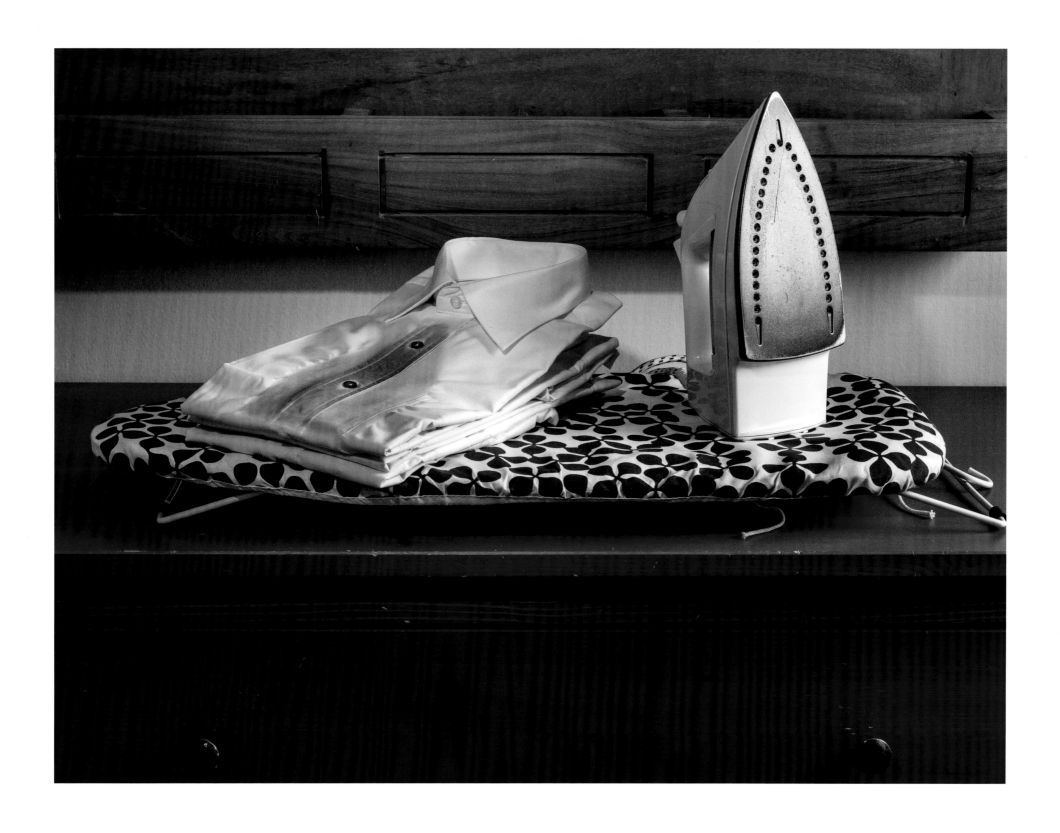

Light (2011)

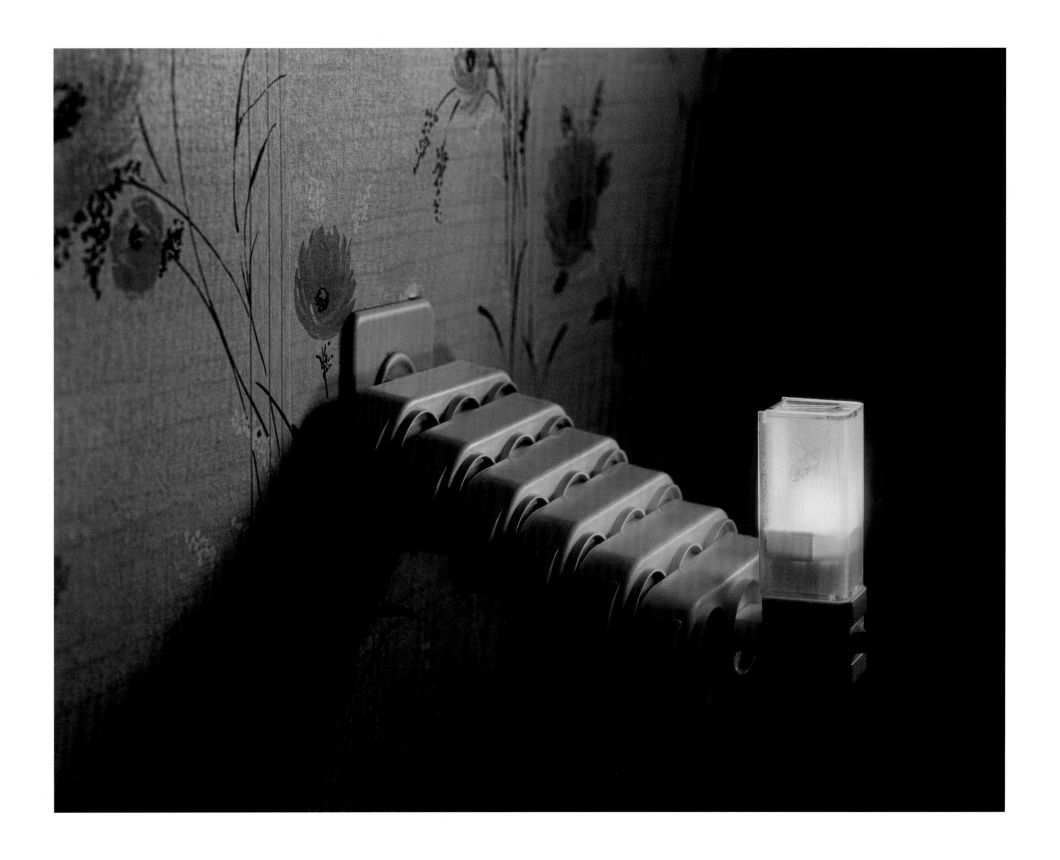

Drawers (2015)

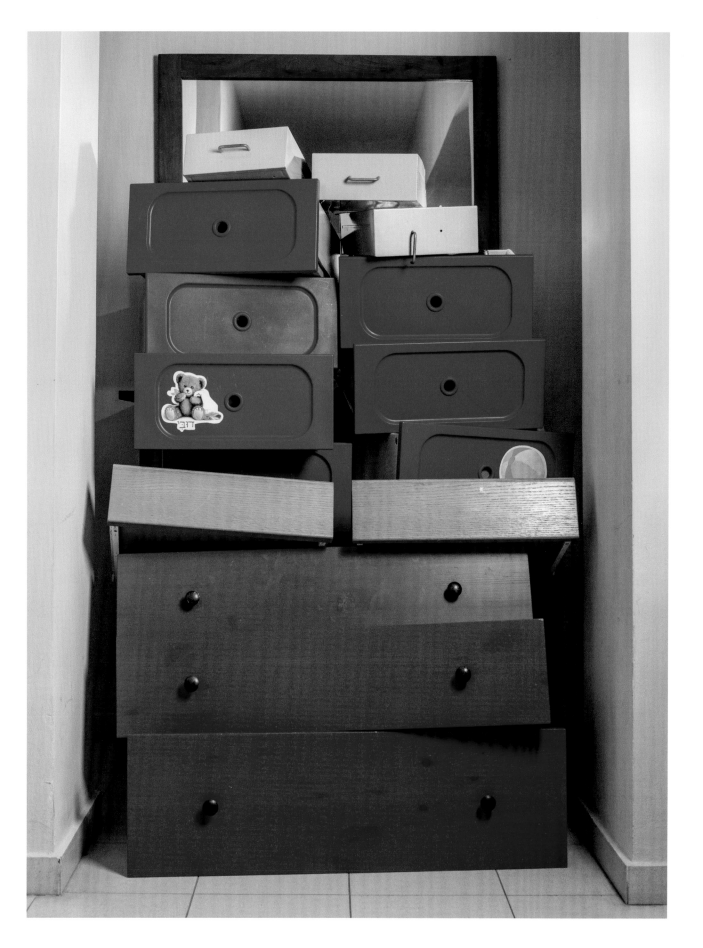

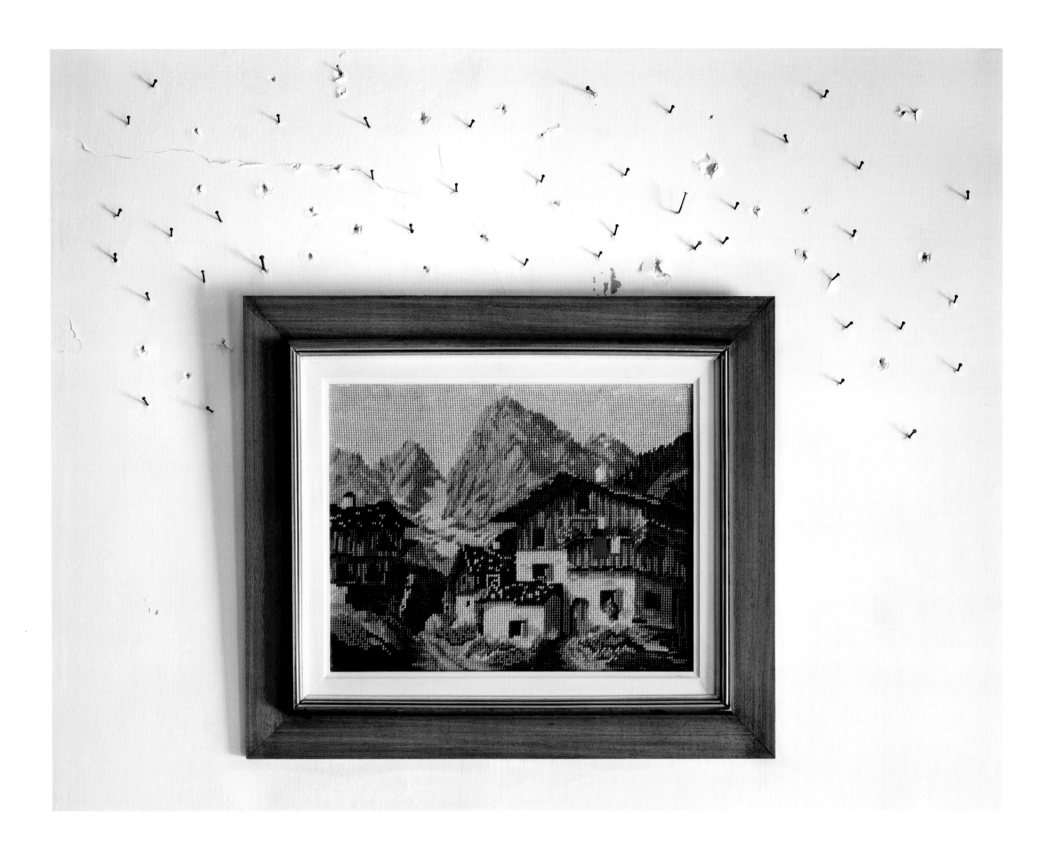

Gobelin (2008)

Spaghetti (2009)

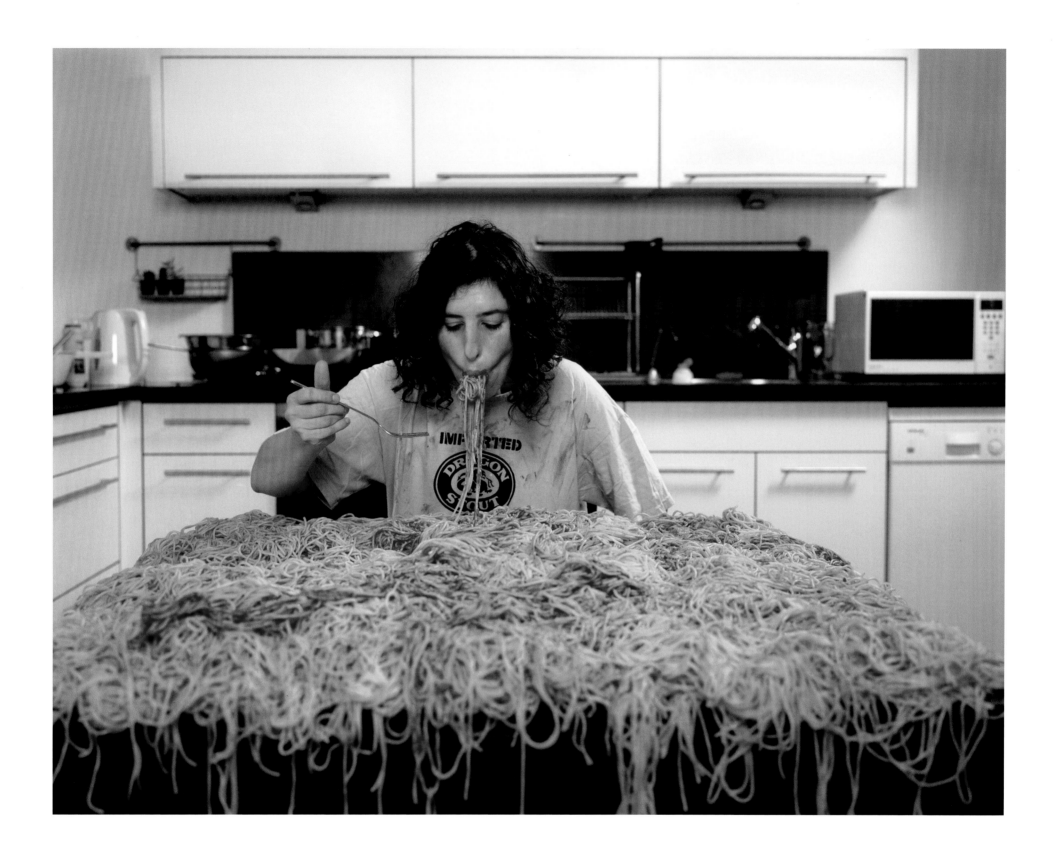

Cats (2008)

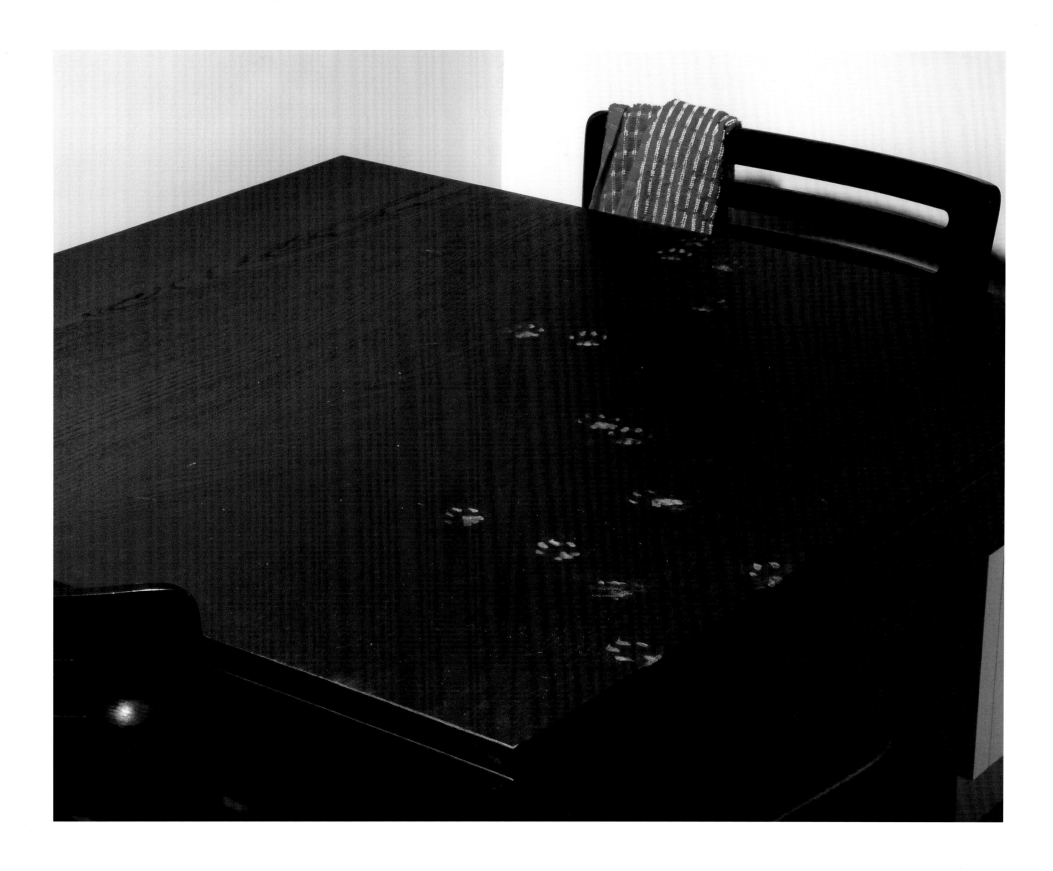

Cribs (2010)

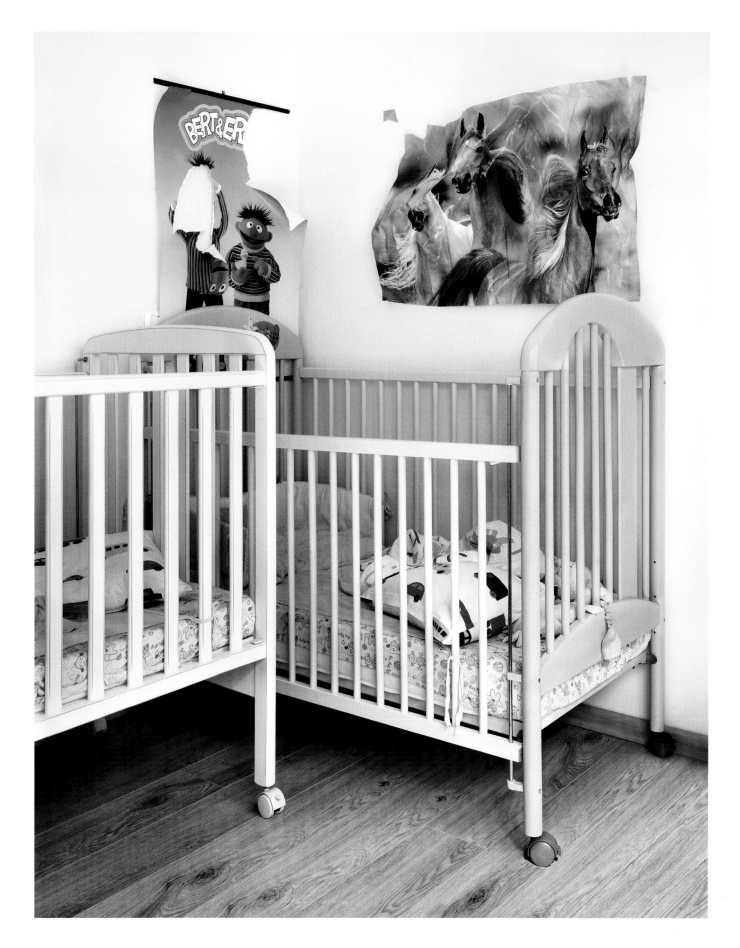

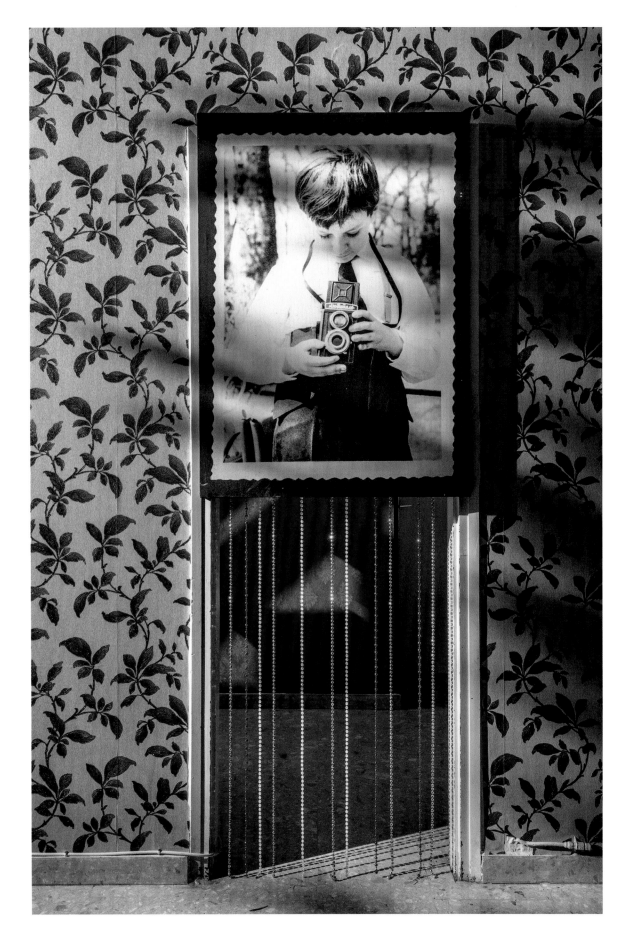

Passage (2015)

Door (2009)

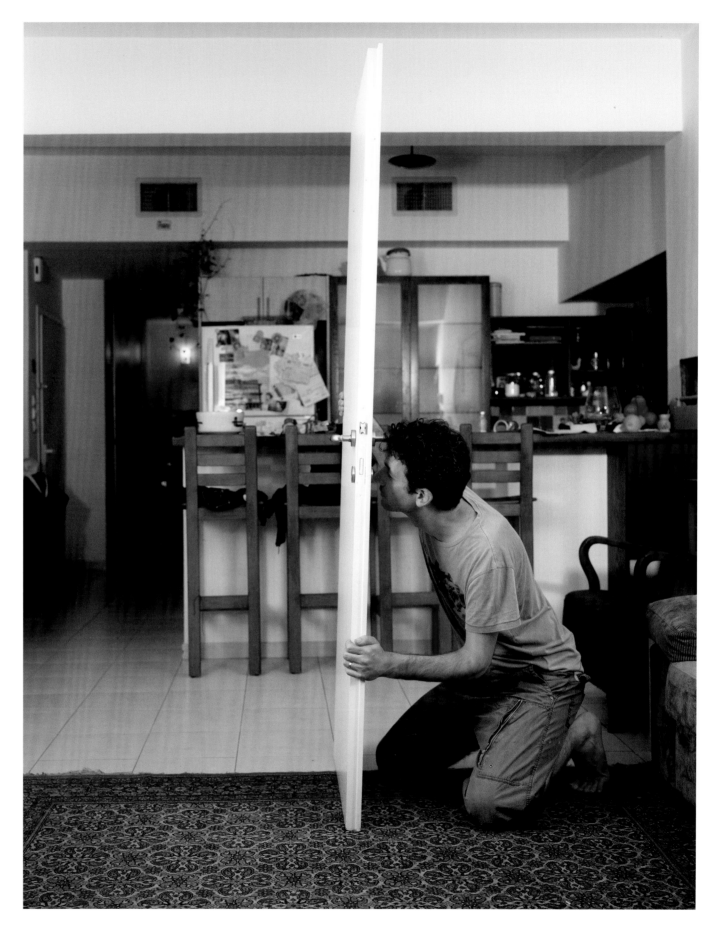

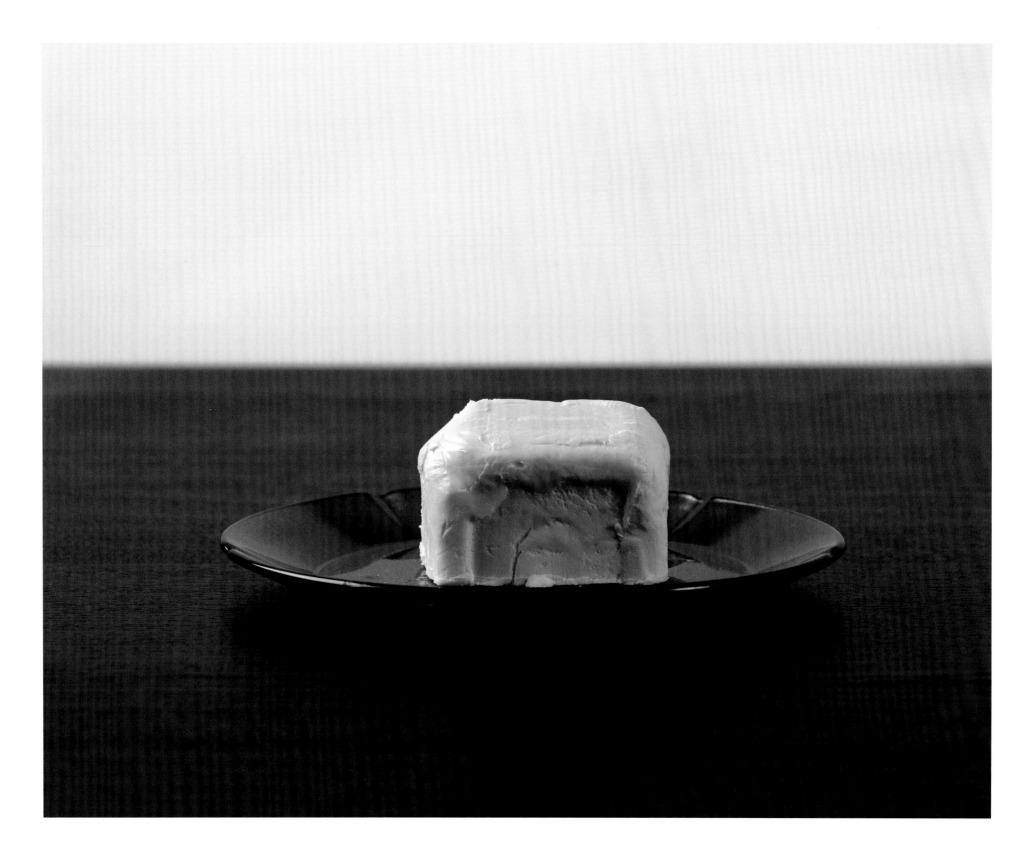

Butter (2008)

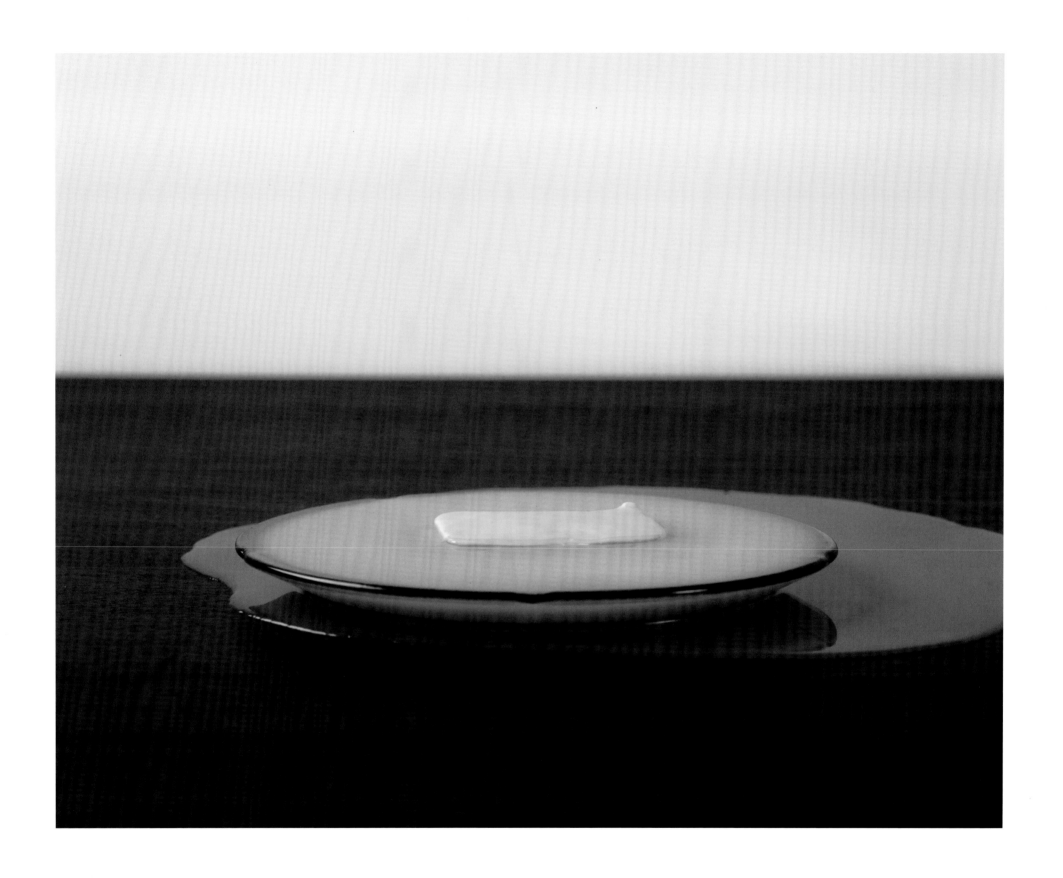

Pacifiers (2009)

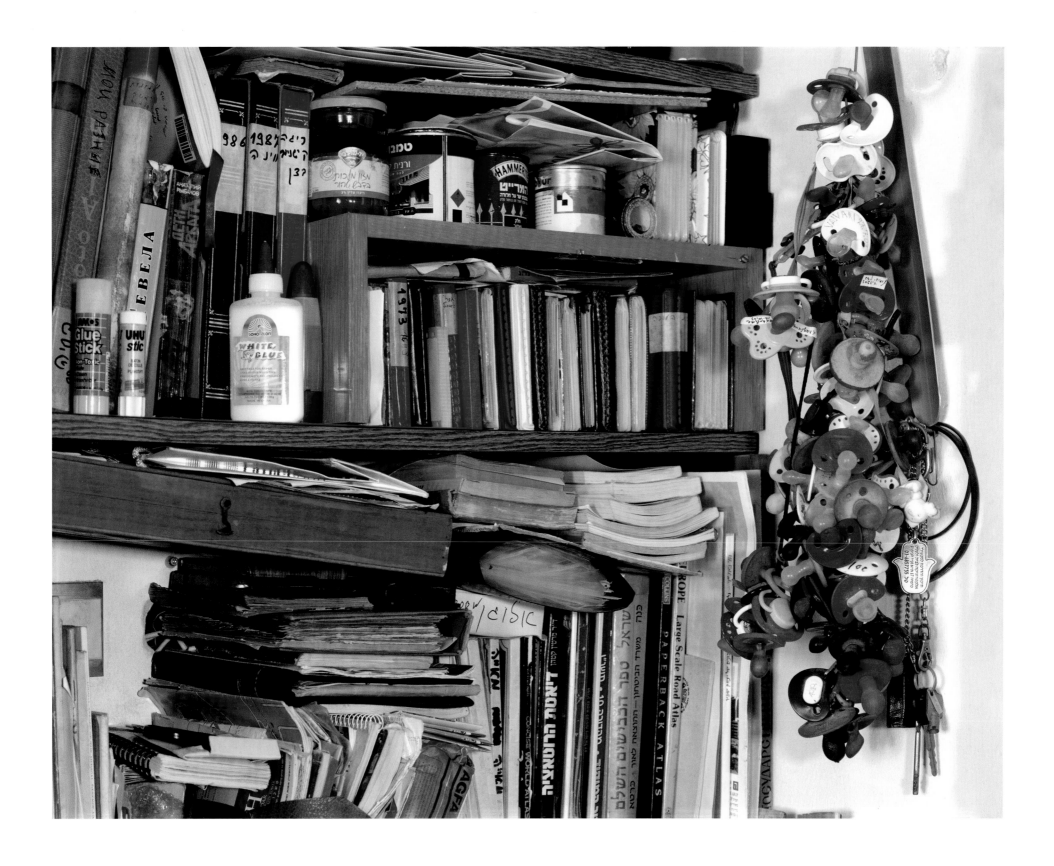

Picture (2014)

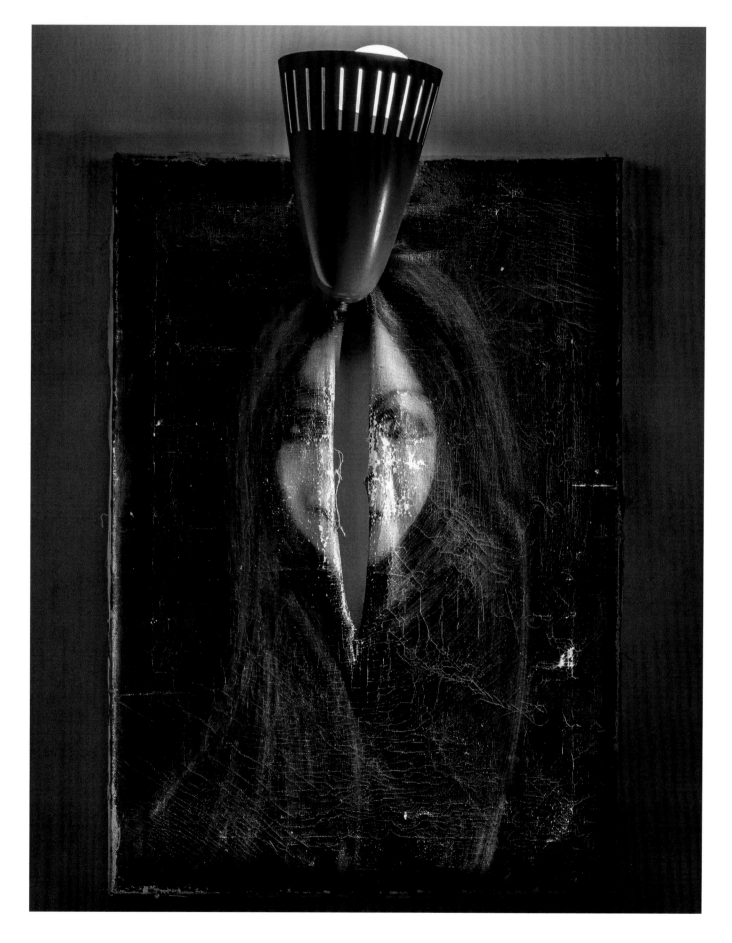

Latex Gloves (2014)

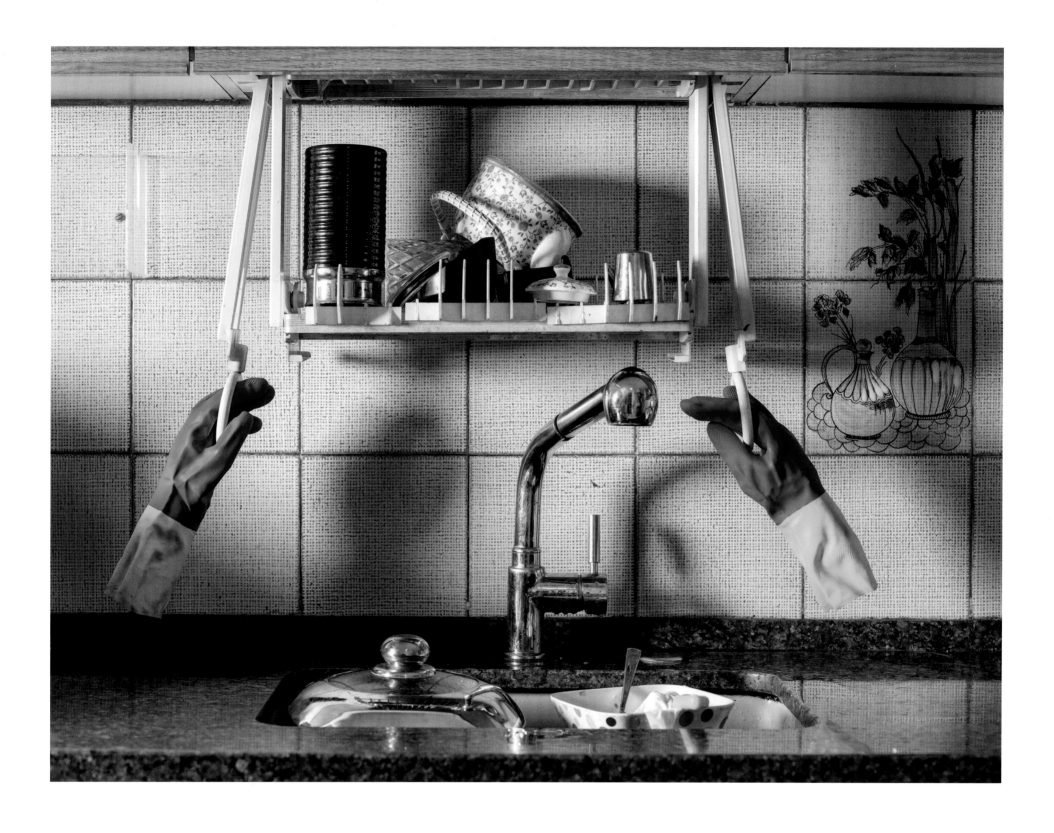

Knife (2013)

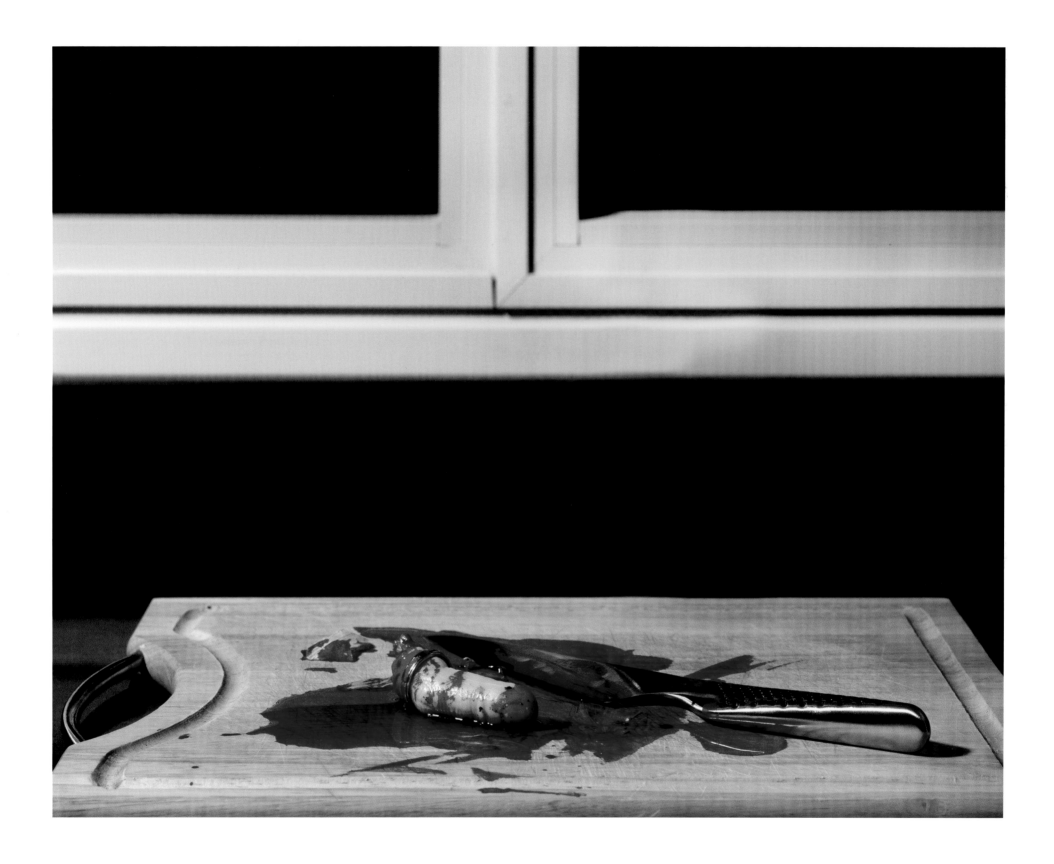

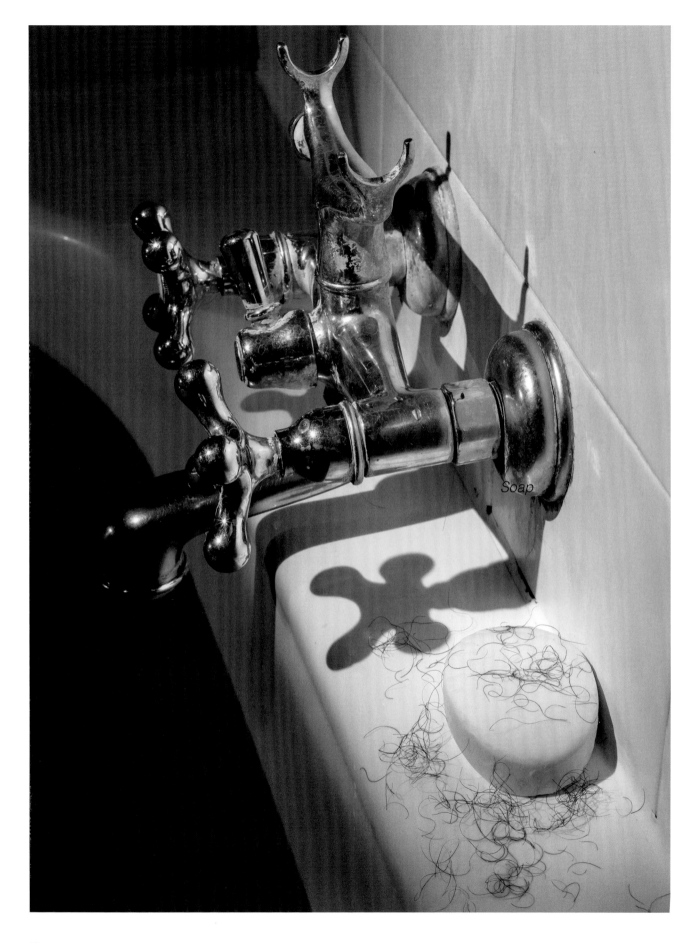

Soap (2015)

Dog (2008)

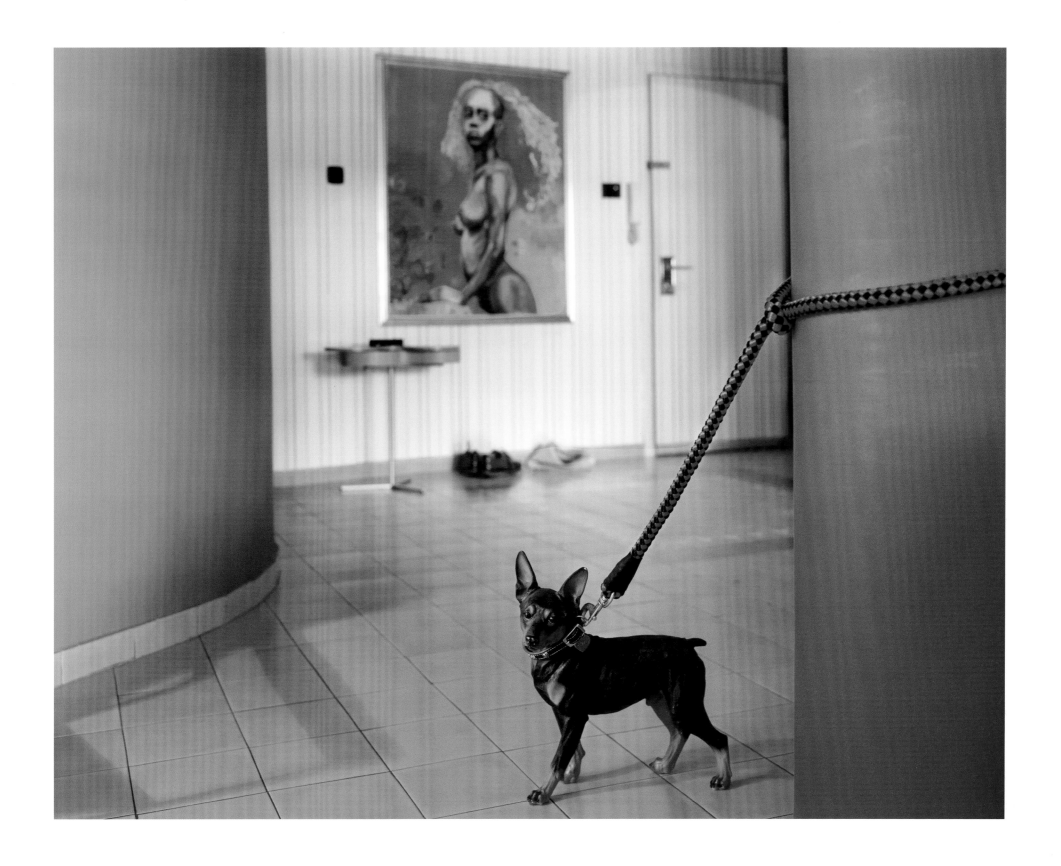

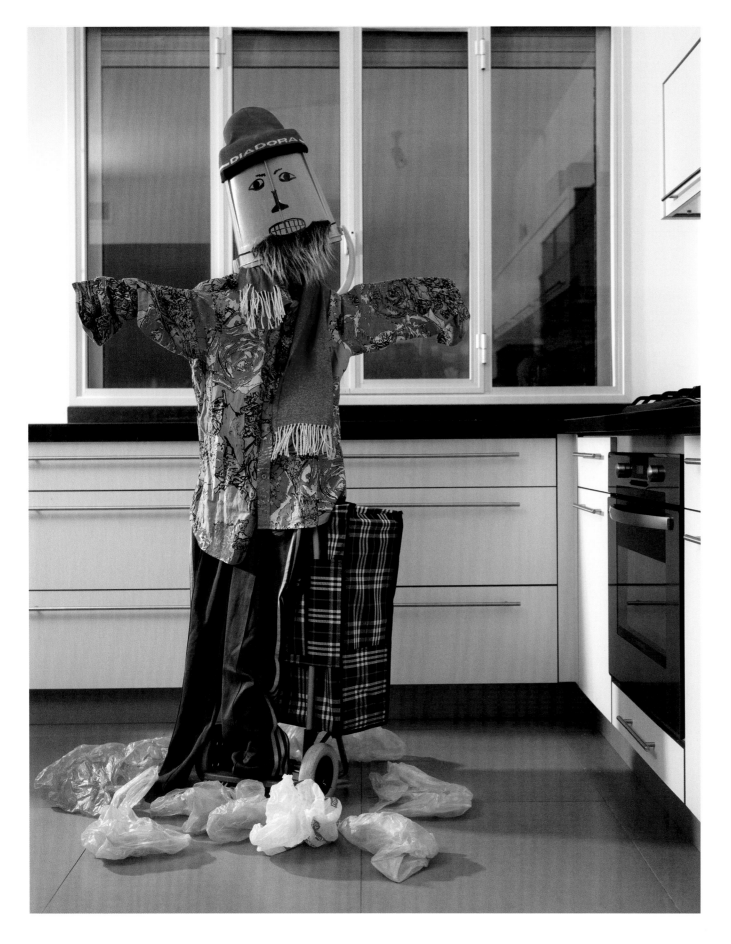

Scarecrow (2010)

Mushrooms (2013)

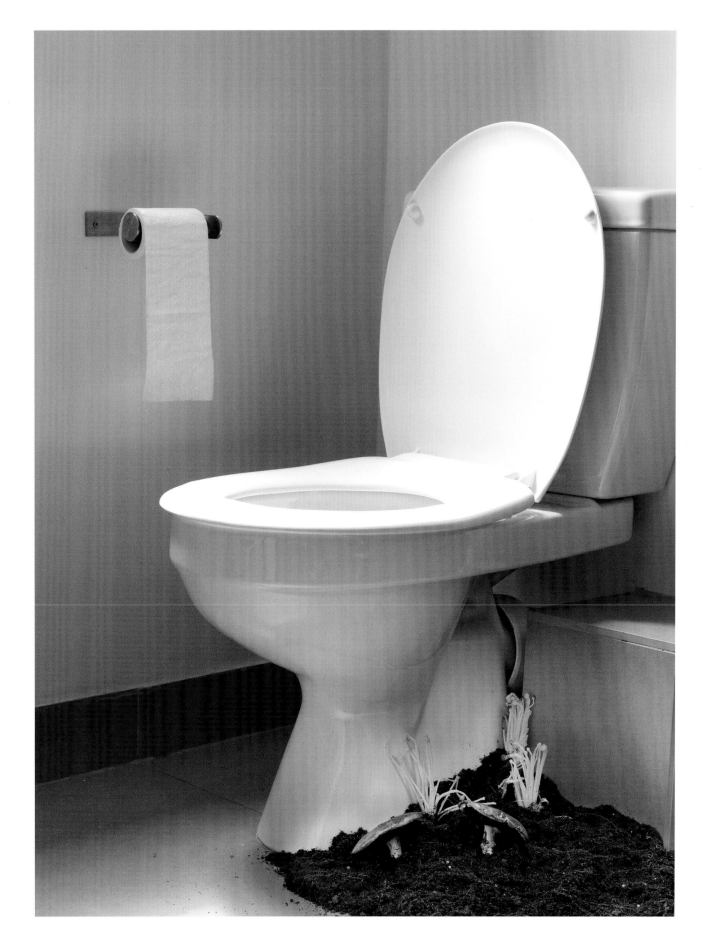

Turntable (2015)

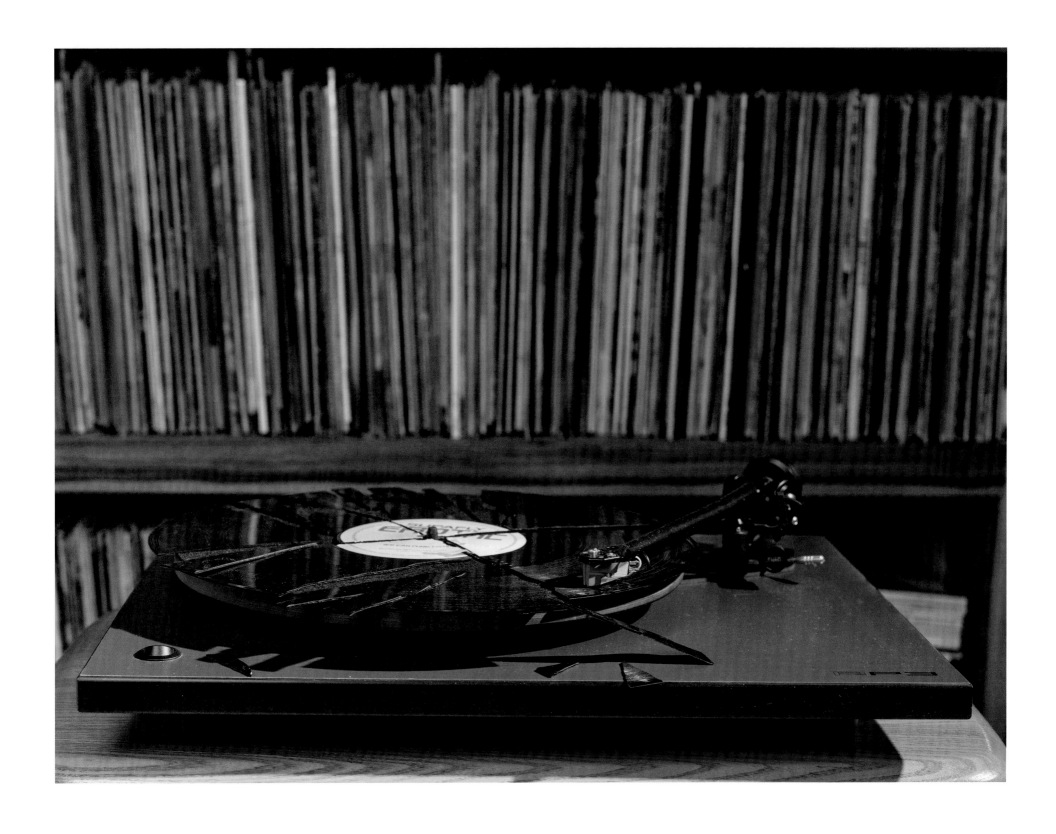

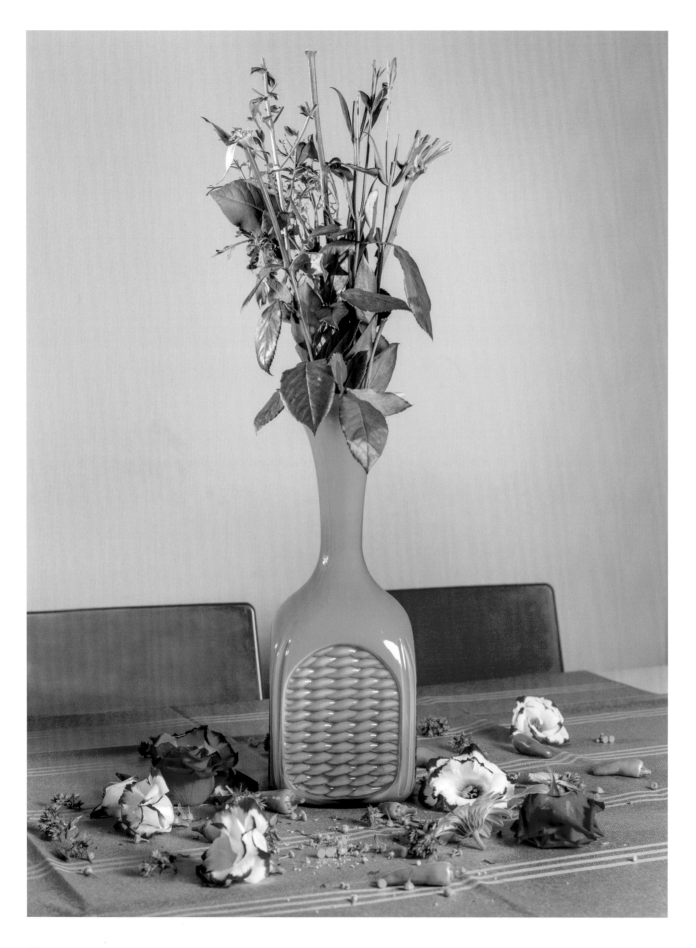

Flowers (2015)

Feathers (2008)

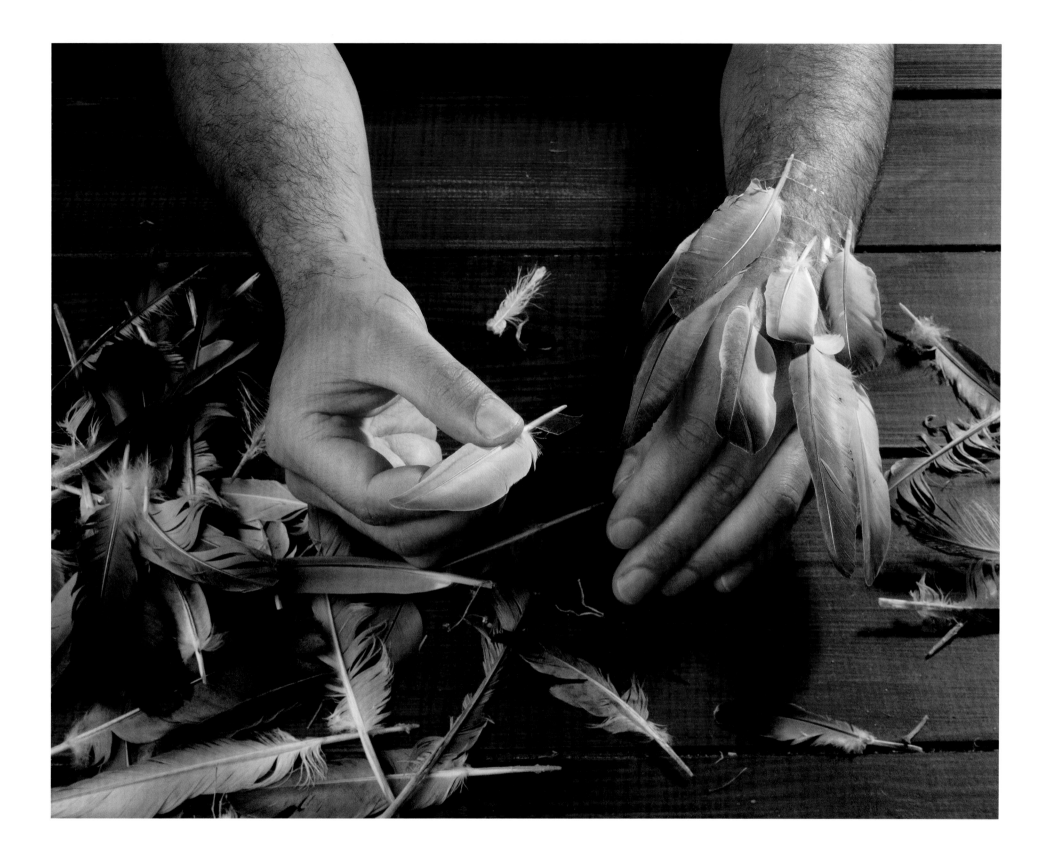

Table (2015)

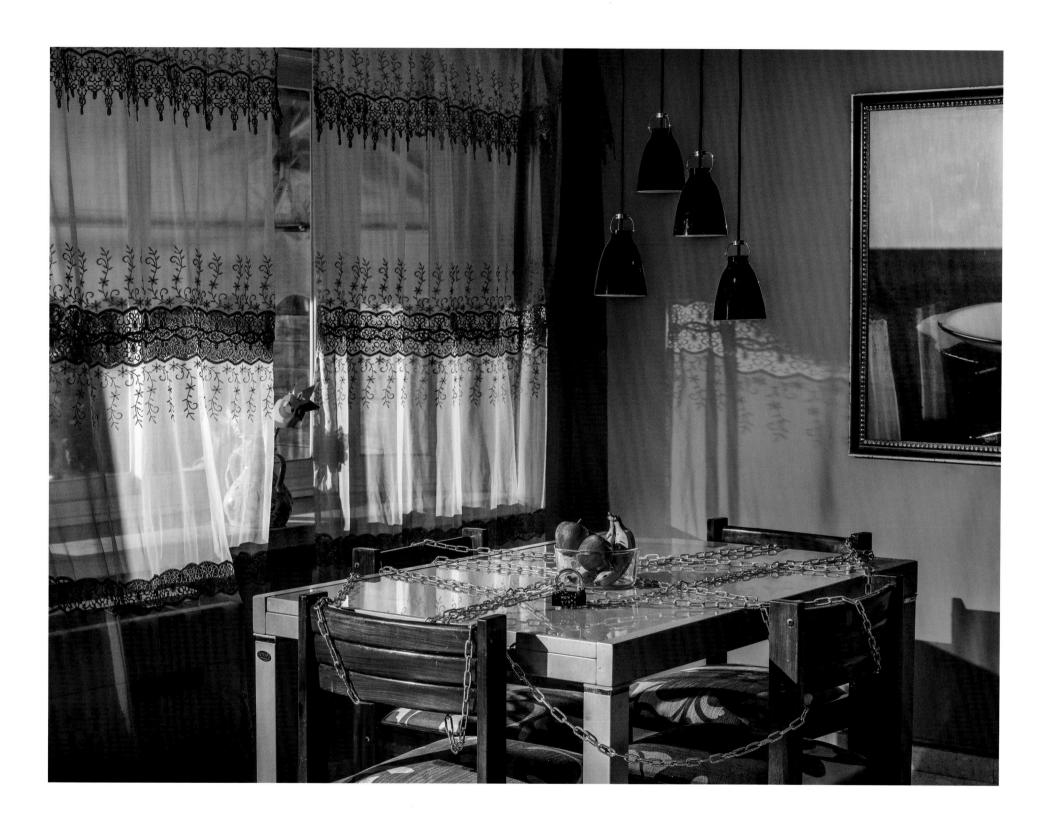

Piano (2010)

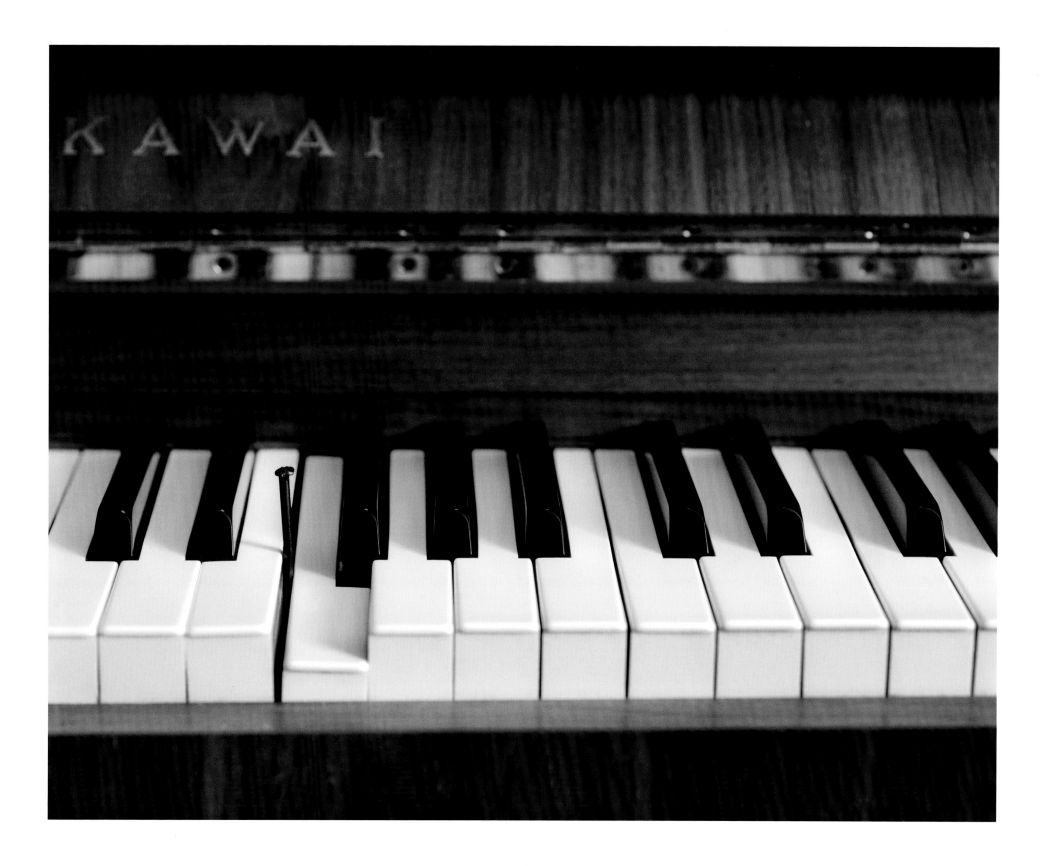

Shelf (2015)

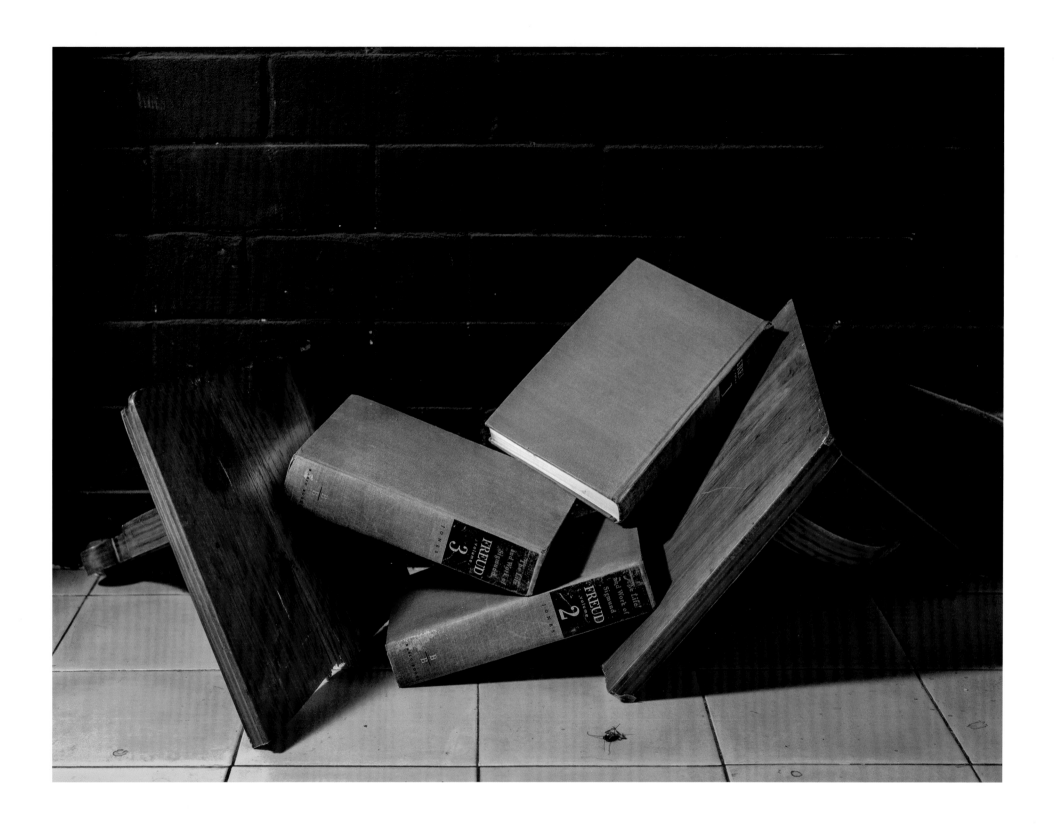

ACKNOWLEDGMENTS

I would like to thank:

Michael Itkoff, for singling me out and giving me the chance to make this book,

Keren Bar-Gil and Lauren and Mitchell Presser, for believing in the project and for being ready to support it financially from its inception eight years ago,

All the curators, magazine editors, bloggers, and fellow artists who have exhibited the project, written about it, and given advice and assistance, including Ann Jastrab, Tricia Hoffman, Hamidah Glasgow, Crista Dix, Amy Wolff, Aline Smithson, J.J. Estrada, Natan Dvir, and Ido Bar-El.

Mary Virginia Swanson, who has always found the time to give me feedback and whose priceless advice was crucial in developing the project,

Eran Bar-Gil and Crista Dix for the wonderful texts they have written for this book, and Joanna Chen for the English translations,

Yoni Passi from the Print House for his help with color correction and retouching,

Ursula Damm and Elizabeth Bell from Daylight Books for their dedication to the improvement of the book,

and special thanks to my wife, Ofra, for her emotional support and boundless patience as each shooting day caused havoc in the house.

Rubi Lebovitch, October 1, 2015, Tel-Aviv

BIOGRAPHIES

Rubi Lebovitch (b. 1974) is a photographer living and working in Tel Aviv, Israel. He received his MFA in art and photography from Bezalel Academy of Art and Design. His latest work is divided between staged domestic scenes and outdoor urban images from different cities around the world. The two subject areas share a common aspect: the relationships between people and the day-to-day objects around them, focusing on their peculiarities and at times accentuating their uncanny aspects.

His photographs have been shown in solo and group exhibitions at galleries and museums around the world. The series Home Sweet Home has been exhibited in several museums and galleries in the United States, including the Museum of Fine Arts Houston, NewSpace Center for Photography in Portland, Rayko Photo Center in San Francisco, and the Center for Fine Art Photography in Fort Collins, Colorado.

Lebovitch's work has received awards from Center Santa Fe, Kaunas Photo Star, Japan Media Art Festival, and the Morton Mandel Fund, among other establishments. His photographs are held in many public institutions such as the Museum of Fine Arts Houston, the Center for Fine Art Photography, and Bank Leumi, as well as in private collections in Israel and abroad.

Eran Bar-Gil is one of Israel's most important literary figures. A novelist, short story writer, poet, and scriptwriter as well as a musician, reporter, and book critic, he has published five novels, four volumes of poetry, and two books of short stories. His work has won major literary awards, including the 2014 Prime Minister's Prize. Bar-Gil lives in the village of Mishar, Israel, with his wife and three sons.

Crista Dix is the founder of wall space gallery in Santa Barbara and Seattle, specializing in unique photographic images with a storytelling orientation. Her background includes activity in theater, science, and business, all culminating in her passion for exploring the intersections of art and science. In addition to managing the gallery, she reviews portfolios at events nationwide and has curated exhibitions across the United States and China.